Portrait of

ALBERTA

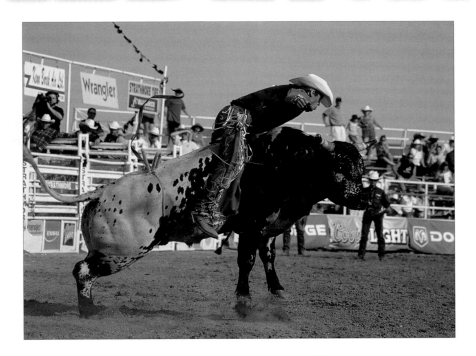

by Andrew Bradley
and Jennifer Groundwater

Altitude Publishing

The Canadian Rockies / Victoria

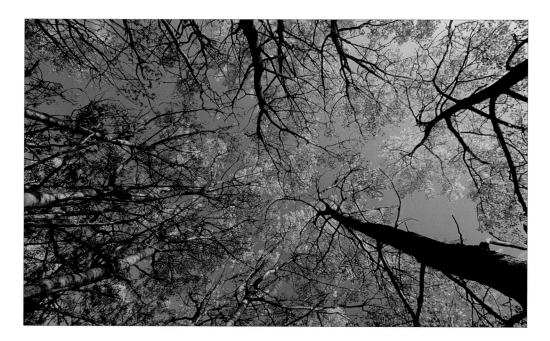

PORTRAIT OF ALBERTA

Photographs copyright 2005© Andrew Bradley
Text copyright 2005© Jennifer Groundwater

Library and Archives Canada Cataloguing in Publication
Groundwater, Jennifer, 1970-

Portrait of Alberta / Andrew Bradley, photographer; Jennifer Groundwater, author.

ISBN 1-55153-231-X (paperback)
ISBN 1-55153-237-9 (hardcover)

1. Alberta--Pictorial works. I. Title.
FC3662.G76 2005 971.23'04'0222 C2005-900662-5

Layout & design: Scott Manktelow

Thanks to

We acknowledge the financial support of the Government of Canada through the Book Publishing Industry Development Program (BPIDP) for our publishing activities.

Altitude Publishing Canada Ltd.
The Canadian Rockies / Victoria
Head office: 1500 Railway Ave.
Canmore, Alberta, T1W 1P6
1-800-957-6888
www.altitudepublishing.com

Printed in Canada
by Friesens Printers

Altitude GreenTree Program
Altitude will plant two trees for every tree used in the production of this book.

Front cover: Upper Waterton Lake in Waterton Lakes National Park
Back cover (hardcover): The badlands of Dinosaur Provincial Park
Front flap (hardcover): Alberta's Legislature Building in Edmonton
Back flap (hardcover): Bronc rider at the Calgary Stampede
Back cover (paperback) and opposite: Nose Hill, in Calgary, the largest municipal park in Canada
Frontispiece: Bull rider at the Strathmore Rodeo
Top: Brilliant aspen trees in Cypress Hills Interprovincial Park

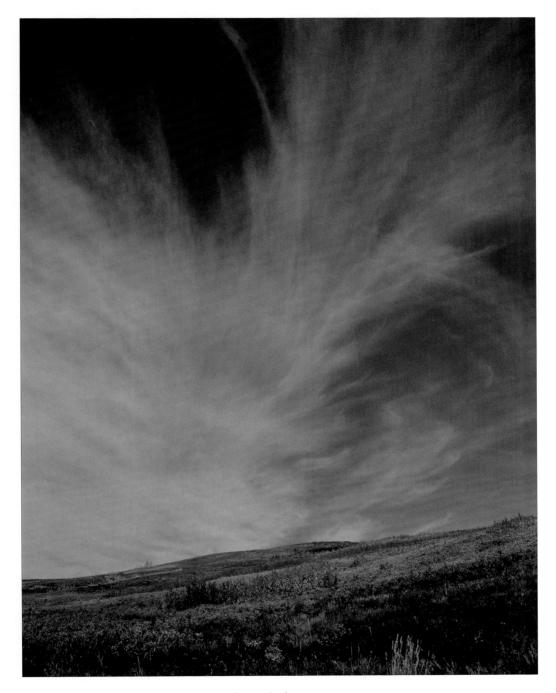

Acknowledgements

I would like to give special thanks to Vistek West Calgary, and in particular
Sam Wolde-Michael, for their continued support of my photographic endeavours;
to my loving wife and best friend for her unswerving faith in our future; and to
Altitude Publishing for making my dream a reality. Thank you to you all.

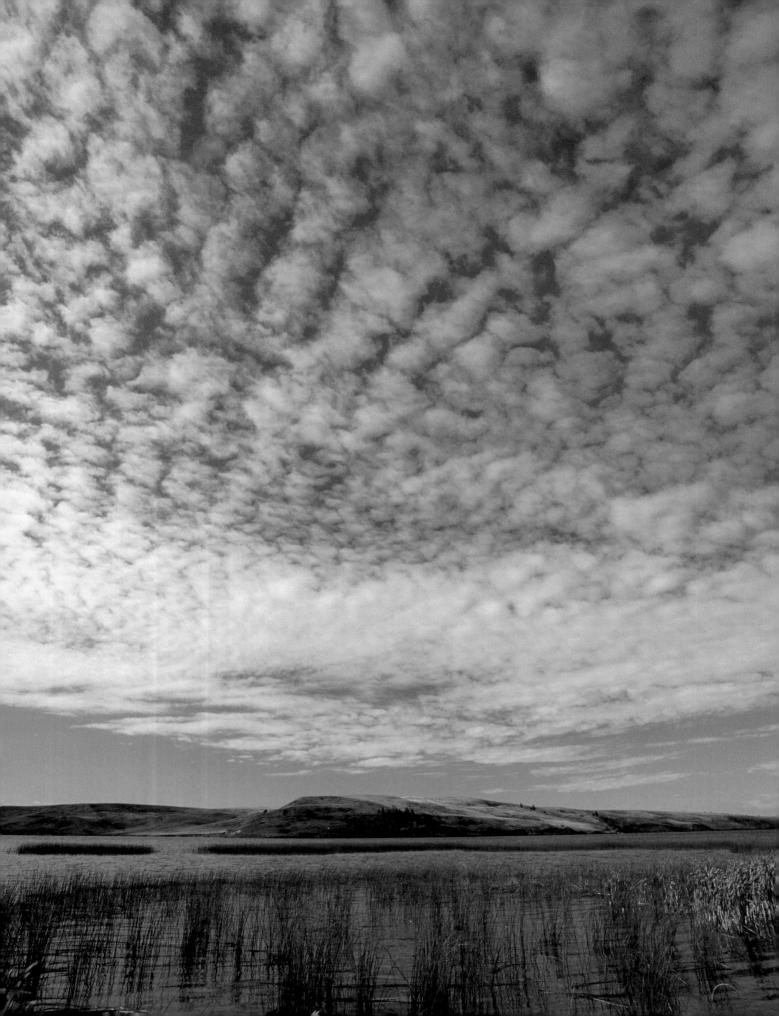

ALBERTA

Alberta is a lucky province, brimming with natural resources and stunning scenery. Canadians envy its bountiful oil and natural gas wealth, while visitors revel in its astonishing range of activities, both outdoor and urban.

The province was once covered by a vast inland sea. As the waters receded, dinosaurs began to roam the land. Today, the bones of over 40 species of dinosaur are found in vast numbers along the Red Deer River valley. These badlands stretch between Drumheller and Dinosaur Provincial Park near Brooks. The Royal Tyrrell Museum of Paleontology in Drumheller explores the rich and fascinating ancient history of the province.

Native peoples of many tribes have been here for thousands of years, fishing from the abundant rivers and hunting across the vast grasslands. The first recorded European explorers reached here in the 18th century, seeking out positions for forts and fur trading posts, and Christian missionaries followed in search of converts.

The Canadian Pacific Railway pushed its way through in the early 1880s, creating hundreds of new towns in the Prairies and bringing a wave of settlers who began to farm and ranch in the District of Alberta (established in 1882 as part of the North-West Territories). It was named for Princess Caroline Louise Alberta, the fourth daughter of Queen Victoria, who visited here in 1881 with her husband, who was then Governor-General of Canada. Scenic Lake Louise in Banff National Park is also named for her. The district became a province on September 1, 1905.

As it steps into its second century of life, Alberta is thriving, with an increasing population. More than half of all Albertans live in Calgary and Edmonton, but smaller cities such as Lethbridge, Medicine Hat, and Red Deer offer plenty of activities and attractions for residents and visitors to experience. The province boasts a diverse offering of cultural events, destinations, and organizations. From outstanding folk music festivals to exceptional museums — plenty of which are located outside the major cities — Albertans enjoy a rich and ever-growing cultural life.

Edmonton, the capital, is located on the banks of the North Saskatchewan River in the centre of the province. Its over 700,000 residents enjoy life in the Festival City, where in summer there is a major special event almost every weekend. The river valley winds throughout the city, and the green spaces surrounding it provide a focus for recreational activities such as walking, cycling, golf, and cross-country skiing. Edmonton is home to the West Edmonton Mall, one of the province's biggest tourism attractions. Millions of people visit the mall every year in search of great shopping and a huge range of activities, from ice skating to splashing in one of the world's finest indoor water parks.

Calgary is one of Canada's largest cities, with a population of over a million. With its prairie location, the city is free to sprawl in all directions from the compact downtown area, and new neighbourhoods spring up continually to house the thousands of new arrivals who pour in every month. The city's history is strongly tied to agriculture and ranching, but its fortunes today are linked to the oil and gas industry, as well as technology and tourism. Calgarians are proud of their roots, celebrating them every year in a massive citywide party known as the "Greatest Outdoor Show on Earth" …the Calgary Stampede.

Calgary is the gateway to the Canadian Rockies, one of the world's most beautiful and pristine wilderness areas. Only one hour west of the city, the traveller enters a landscape of towering mountains, rushing turquoise rivers, and abundant wildlife. Banff and Jasper National Parks, together with Waterton Lakes National Park in the southwest of the province, are Alberta's crown jewels. Millions of international visitors pass through these areas every year, taking home memories of exceptional sightseeing and outdoor activities. The towns of Banff, Jasper, Canmore and Waterton cater to these mountain visitors, offering comfort and even luxury in the very heart of the wilderness.

Outside the major cities, smaller towns and hamlets offer a wide range of experiences, from ranching vacations in the south to unparalleled fly-in fishing in the north. It would take more than a lifetime to explore it all. These pages offer a tantalizing glimpse into the past and present of Alberta. May they inspire you to discover more of this unforgettable province for yourself.

Opposite: Elkwater Lake in Cypress Hills Interprovincial Park, with its reeds and grasses, provides plenty of food for aquatic birds and moose. Cypress Hills is open year-round for summer activities such as hiking, fishing, camping and swimming, while winter offers downhill and cross-country skiing.

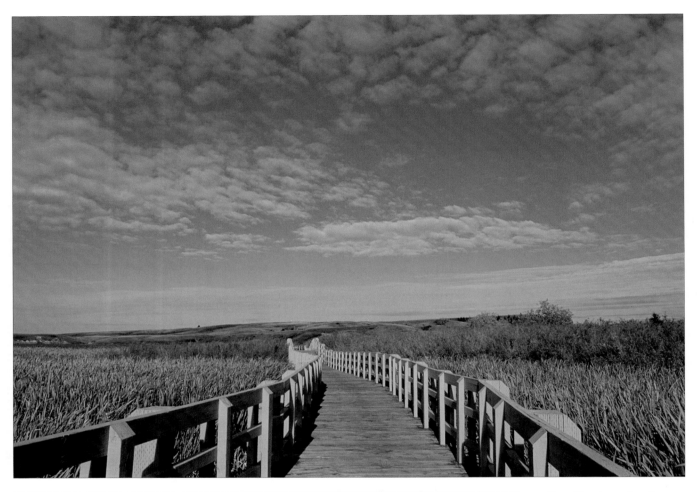

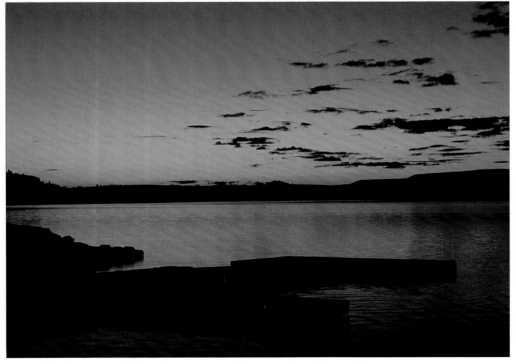

Top: The boardwalk provides an easy stroll along the south shoreline of Elkwater Lake in Cypress Hills Interprovincial Park, an excellent site for birdwatchers. It's part of the Trans Canada Trail, which is the longest recreational trail in the world.

Bottom: Sunset paints Elkwater Lake with a vibrant hue. Cypress Hills is an interprovincial park, straddling Saskatchewan and Alberta. Its cool pine forests offer a startling change from the hot, rolling grasslands that surround the park.

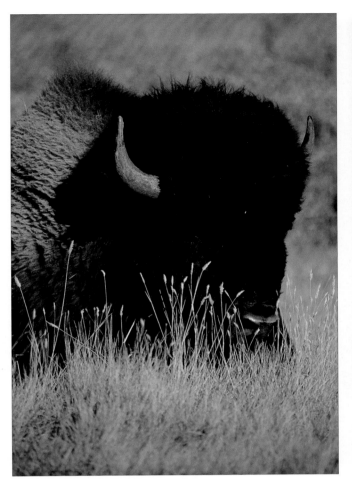

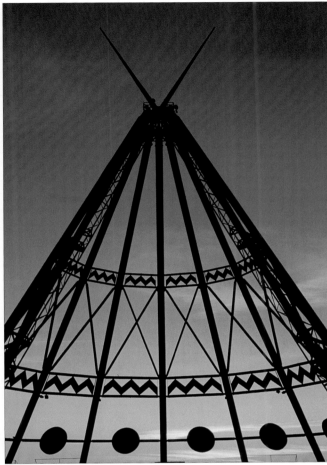

Top left: The buffalo (or bison) once roamed the North American prairies in astonishing numbers, but came close to extinction by the end of the 19th century. Today, the beleaguered animals are making a comeback in protected areas.

Top right: The World's Tallest Tepee attracts much attention next to the Trans-Canada Highway in Medicine Hat.

Bottom: A mural in Medicine Hat evokes the history of the city, from its native roots through pioneer days.

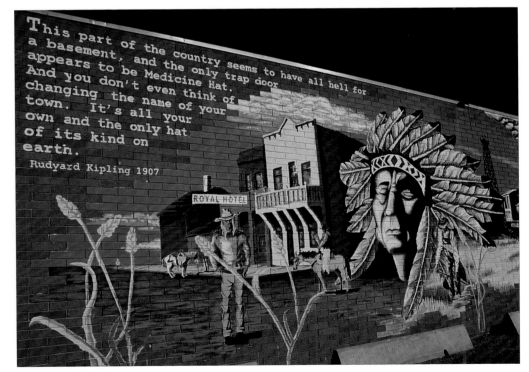

This part of the country seems to have all hell for a basement, and the only trap door appears to be Medicine Hat. And you don't even think of changing the name of your town. It's all your own and the only hat of its kind on earth.

Rudyard Kipling 1907

ROYAL HOTEL

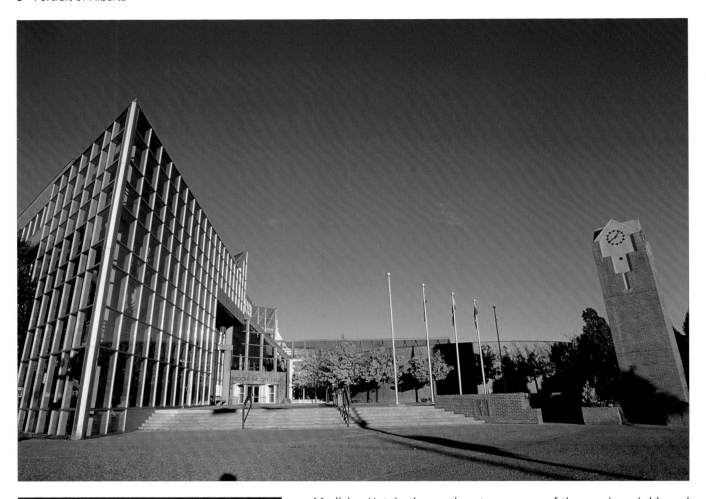

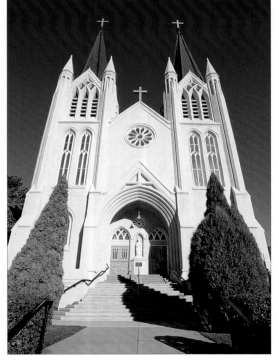

Medicine Hat, in the southeastern corner of the province, is blessed with immense natural gas reserves only 300 metres below the city's surface. During a 1907 visit, Rudyard Kipling referred to it as a place with "all Hell for a basement."

Top: Glass and steel come together to form Medicine Hat's award-winning City Hall.

Bottom: The twin spires of St. Patrick's Cathedral seem to pierce Medicine Hat's sky. The Gothic revival-style building took almost two decades to complete.

Opposite top: Dinosaur Provincial Park, near Brooks, is nestled in an eerie, eroded badlands landscape. Only about a third of the park is open to visitors; the rest is closed to protect the vast deposits of dinosaur bones that are being excavated by paleontologists.

Opposite bottom left: The Brooks Aqueduct is unique in the world. It was completed by the Canadian Pacific Railway in 1914 to carry much-needed irrigation water to southeastern Alberta. Decommissioned in 1969, it's now a national and provincial historic site.

Opposite bottom right: Oil wells methodically extract black gold.

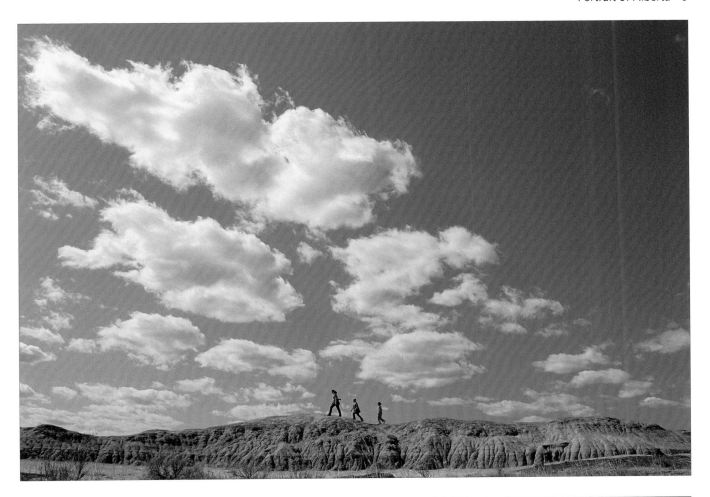

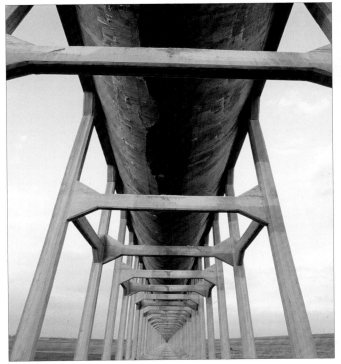

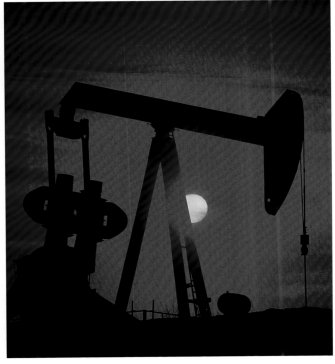

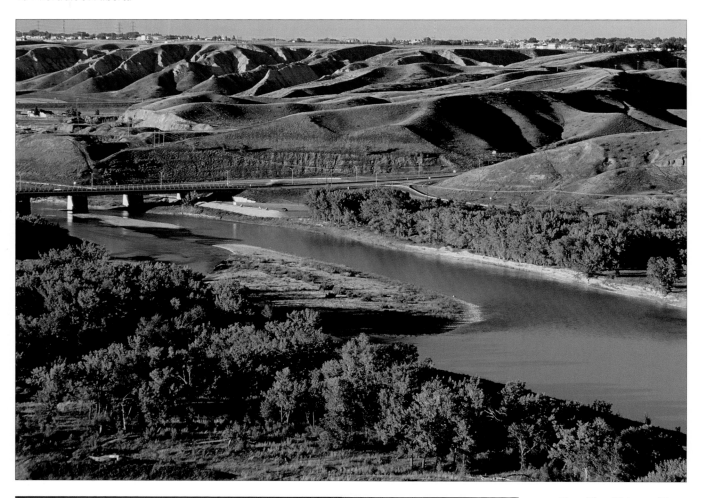

Top: The Oldman River winds through the coulees of Lethbridge in southern Alberta. The coulees were created by water flowing from receding glaciers many thousands of years ago, and now provide residents with a wealth of recreational opportunities, such as walking, fishing, and birdwatching.

Bottom: The High Level Bridge, completed in 1909, is one of Lethbridge's most picturesque attractions. Spanning the Oldman River valley, with a total length of 1.8 km, it is the highest and longest steel railway bridge in the world.

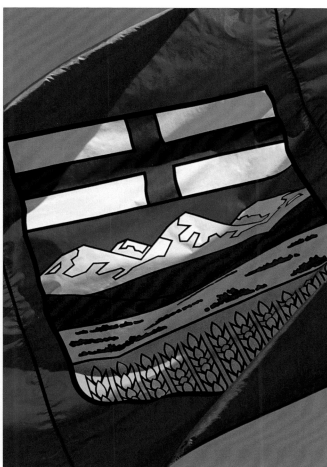

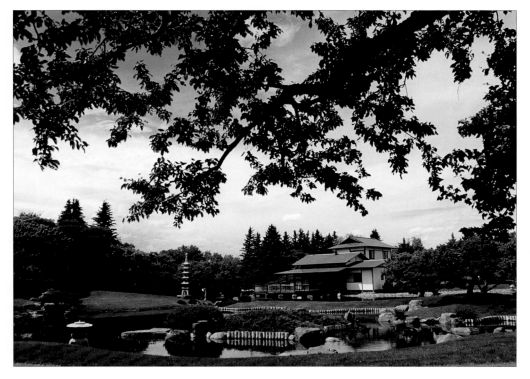

Top left: The curving lines of Lethbridge's City Hall.

Top right: The provincial flag features the shield from Alberta's coat of arms on a field of ultramarine blue. A red and white St. George's cross was the official flag of the Hudson's Bay Company. The mountains, foothills, prairies and wheat fields echo the province's landscape.

Bottom: Nikka Yuko Japanese Gardens commemorate the friendship between Canada and Japan. Pictured here is the Island and Pond Garden in front of the central Pavilion.

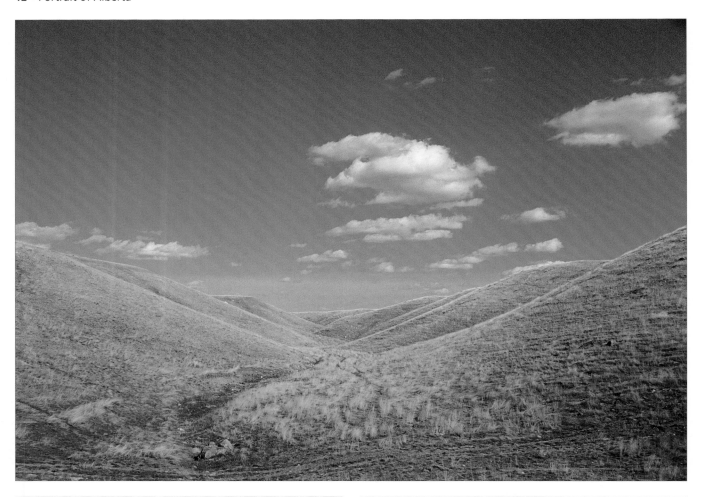

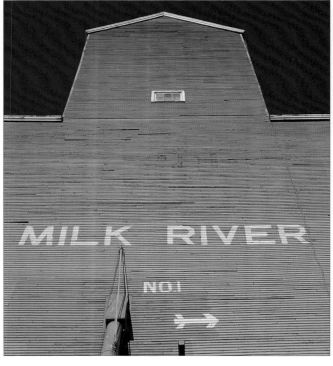

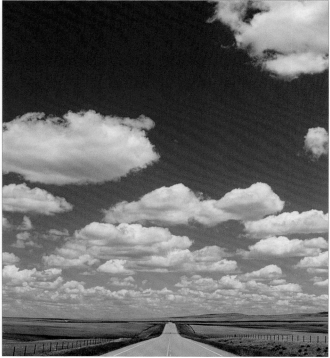

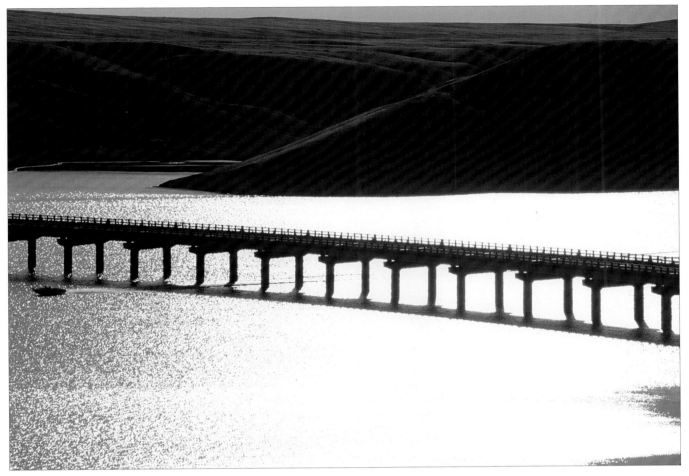

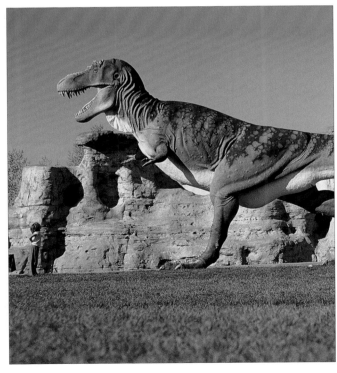

Opposite top: You can practically hear the crickets chirping in this image of the rolling prairie on a sunny day in southern Alberta.

Opposite bottom left: Grain elevators are vanishing all over western Canada as agriculture becomes more centralized, but once each small town had one. Now they are remnants of a bygone era, like this one in Milk River.

Opposite bottom right: In a perfect world, every trip would involve the open roads and the endless blue sky of Alberta.

Top: Highway 36 crosses Chin Lake, near Taber. This irrigation reservoir is a popular place for locals to fish, swim and boat.

Bottom: A life-size model of a T. Rex greets visitors to the Milk River Visitor Information Centre. The first dinosaur discoveries in Alberta were made near Milk River in 1874.

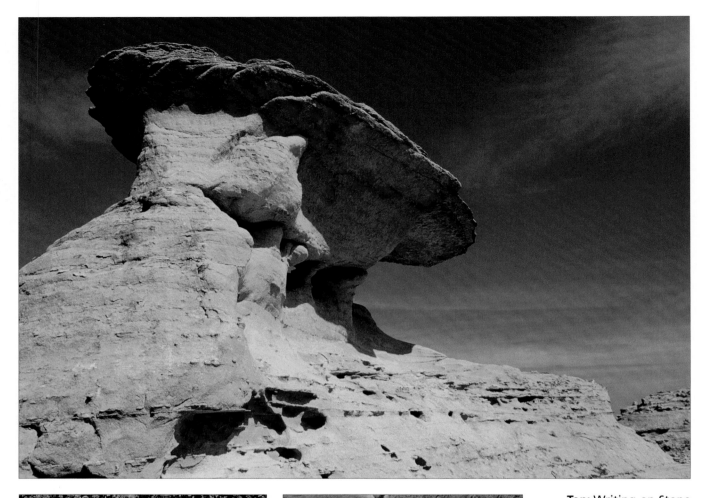

Top: Writing-on-Stone Provincial Park is home to a wide swath of protected grassland, the Milk River's meandering waters, and a gathering of weirdly eroded sandstone hoodoos.

Bottom left: Brightly coloured lichens growing in the badlands of southern Alberta.

Bottom right: Writing-on-Stone also contains the largest concentration of native pictographs (rock paintings) and petro-glyphs (rock carvings) in North America, contained within an archaeological preserve.

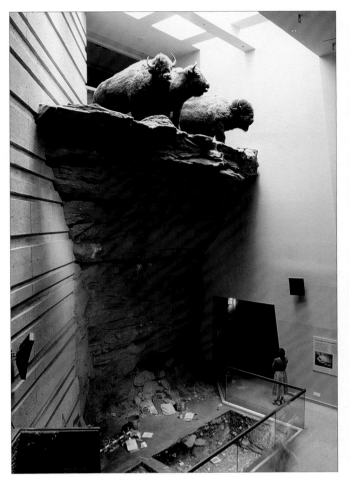

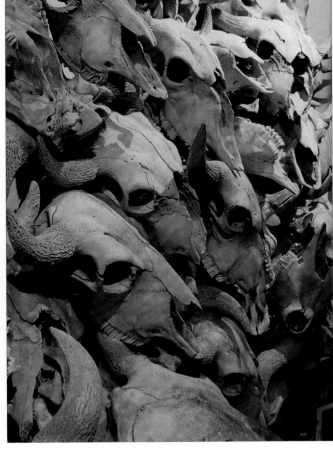

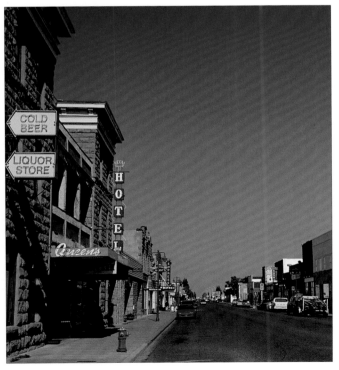

Top left: Three stuffed bison look down on visitors to Head-Smashed-In Buffalo Jump Interpretive Centre. This UNESCO Heritage Site is a fascinating monument to the Blackfoot people and their way of life.

Top right: The Blackfoot used buffalo jumps like the one at Head-Smashed-In to herd buffalo to their deaths. When the bodies piled up at the bottom of the cliff, the clan would feast. Then every part of the buffalo, save the skull, was used for food, clothing or shelter.

Bottom: With its wide streets and wooden buildings, downtown Fort Macleod retains a real frontier feeling. This Provincial Historic Area is home to the fascinating Fort Museum of the North West Mounted Police.

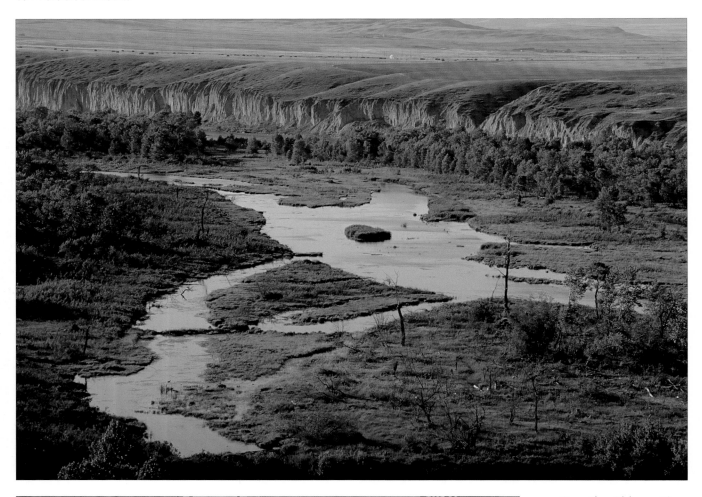

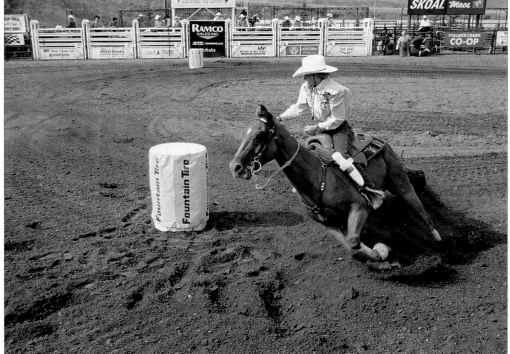

Top: The Oldman River wends its way through a verdant valley bordered by majestic cliffs near Brocket in southwestern Alberta.

Bottom: Barrel racing is a rodeo event for horse-women. Riders enter the arena and gallop at top speed around three barrels in a cloverleaf pattern.

Opposite: It's always gusty in Pincher Creek, which makes this area in south-western Alberta an ideal location for wind farms. Renewable and non-polluting, wind is used as an alternative energy source to fossil fuels.

WIND GUSTS

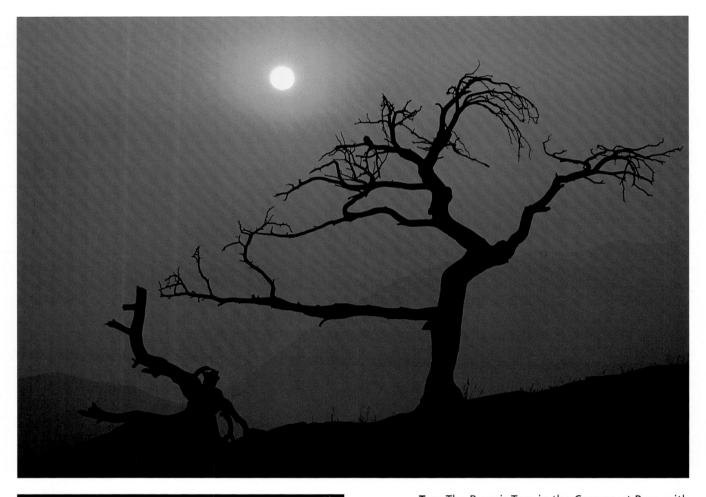

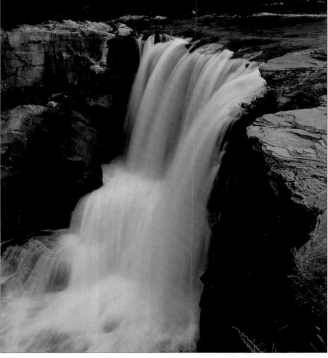

Top: The Burmis Tree in the Crowsnest Pass, with its gnarled, desiccated limbs, is surely the most-photographed tree in Alberta. Most travellers would never guess that this long-dead tree was actually once a limber pine, but all find something stirring in its solitary, windswept location

Bottom: Lundbreck Falls, near Pincher Creek, is a lovely place to while away a sunny afternoon. Paddlers and fishermen love the cool waters, and swimmers can take a dip below the falls.

Opposite top: From 1909 until the 1920s, the Winnipeg Supply and Fuel lime kilns turned the limestone near the Frank Slide into cement. Now their ruins sit quietly beside Highway 3.

Opposite bottom left: A Columbian ground squirrel takes a peek at its surroundings.

Opposite bottom right: Coleman is one of the small communities that make up the area in Alberta's southwest known as the Crowsnest Pass.

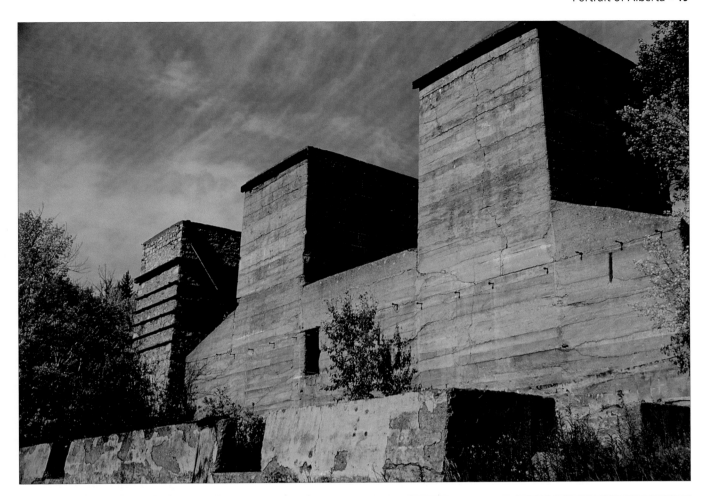

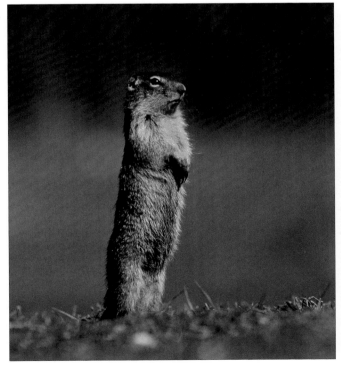

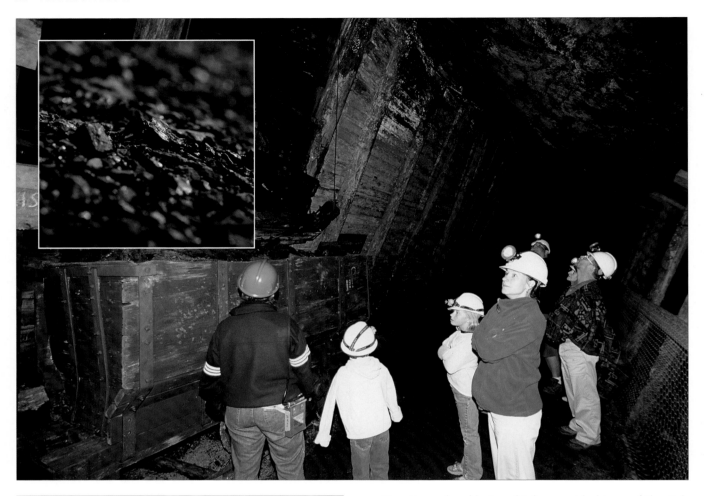

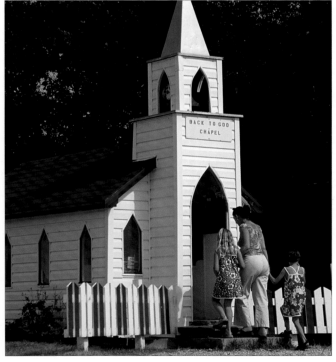

Top: Don a hard hat and take a guided tour of the Bellevue Mine — it's sure to make you look at your own job with renewed appreciation. The darkness of the mine shaft is matched only by the blackness of the coal that was mined here for over 60 years **(inset)**.

Bottom: A minuscule church beside Highway 3 in Bellevue beckons some curious visitors.

Opposite top: Gold Creek lives up to its name as it rushes below Turtle Mountain during the fall.

Opposite bottom left: The small town of Bellevue sits peacefully at the base of Turtle Mountain. In 1903, the nearby village of Frank was completely devastated by a massive landslide from this same mountain, the remnants of which are visible in this photo.

Opposite bottom right: Leitch Collieries was begun with high hopes by an all-Canadian group. Despite its ambitious beginnings, it produced coal for only six years before closing in 1915. Its atmospheric ruins are now a provincial historic site.

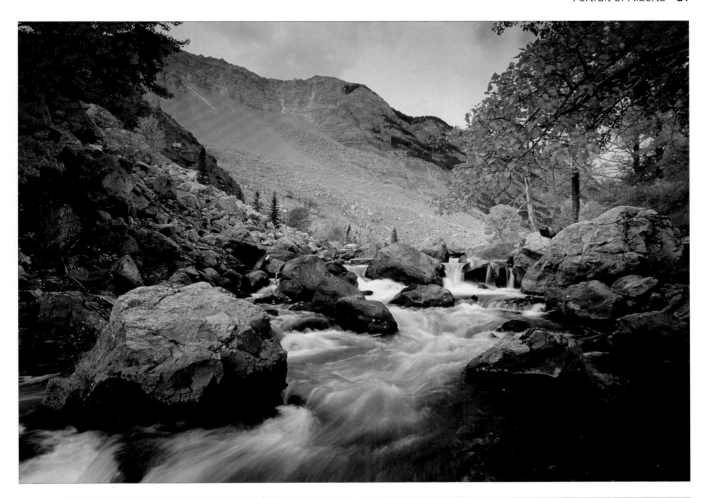

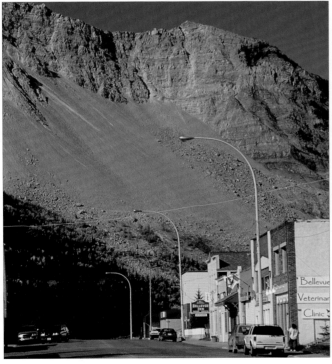

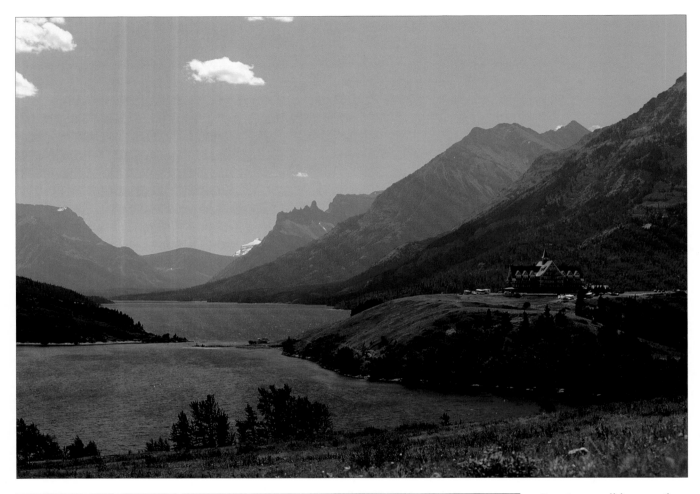

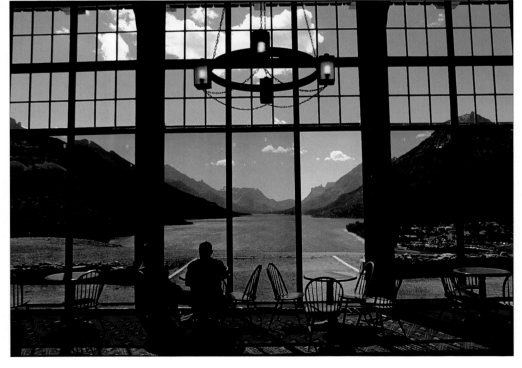

Top: Less well-known than Banff and Jasper, Waterton Lakes National Park is still absolutely stunning.

Bottom: The lobby of the Prince of Wales Hotel has a superb viewpoint above Upper Waterton Lake.

Opposite top: Mount Blakiston (9,600 feet) is the highest peak in Waterton Lakes National Park.

Opposite bottom left: Red Rock Canyon's rich rusty tones come from iron in the rock that has oxidized.

Opposite bottom right: Blakiston Falls cascade into a clear green pool.

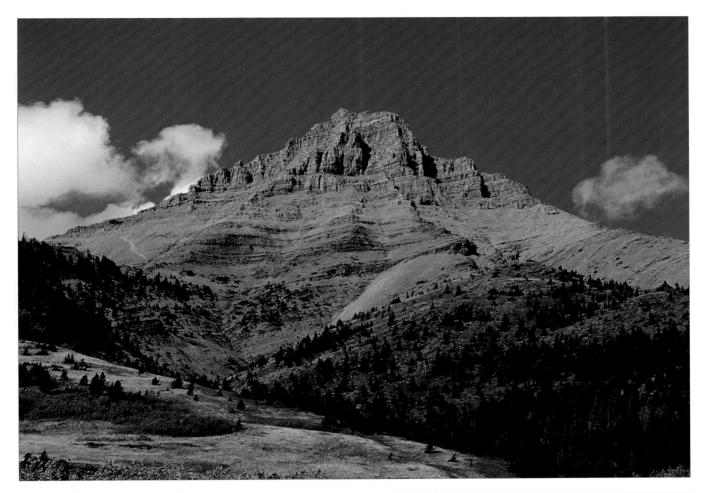

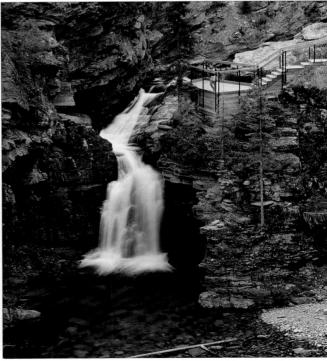

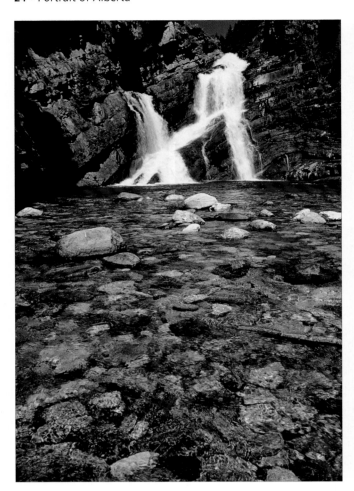

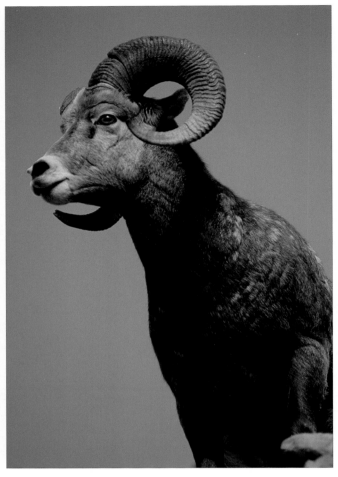

Top left: Cameron Falls is tucked away at the edge of Waterton townsite. The town offers accommodation, shopping, and dining from Easter through Thanksgiving. Most park facilities are closed in winter.

Top right: A bighorn sheep peers over its rocky perch. These majestic animals are common sights along the roadsides of Waterton National Park and throughout Alberta's Rocky Mountains.

Bottom: A winding road offers the possibility of adventures in the foothills of southern Alberta.

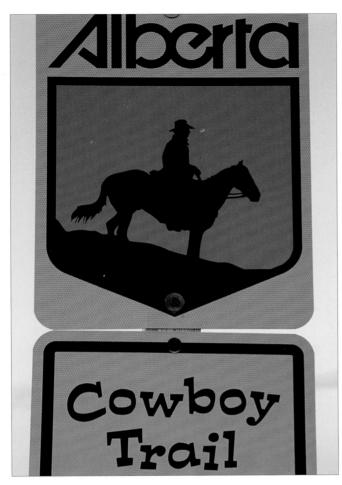

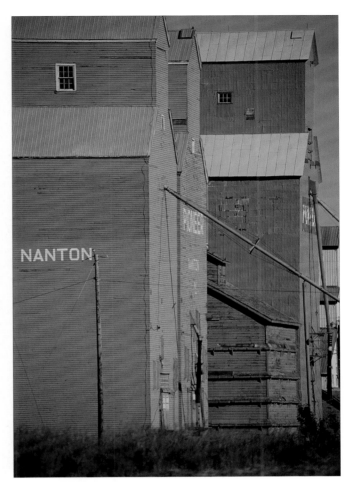

Top left: The Cowboy Trail follows Highway 22 through 700 km of Alberta's picturesque foothills ranching country. Travellers can visit working ranches and historic sites to participate in cowboy activities.

Top right: Nanton's grain elevators, like those all over Alberta, are now historic relics. Local residents are working hard to preserve the elevators as a testament to the area's history.

Bottom: Rolling fields of wheat with the Rocky Mountains in the distance.

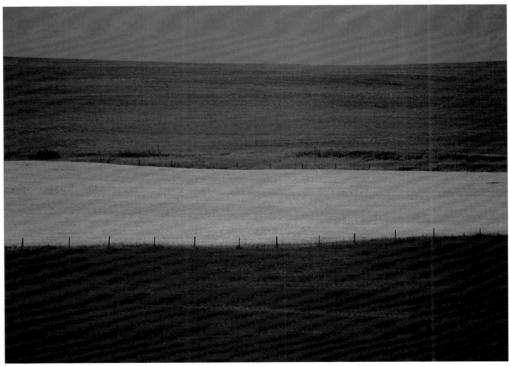

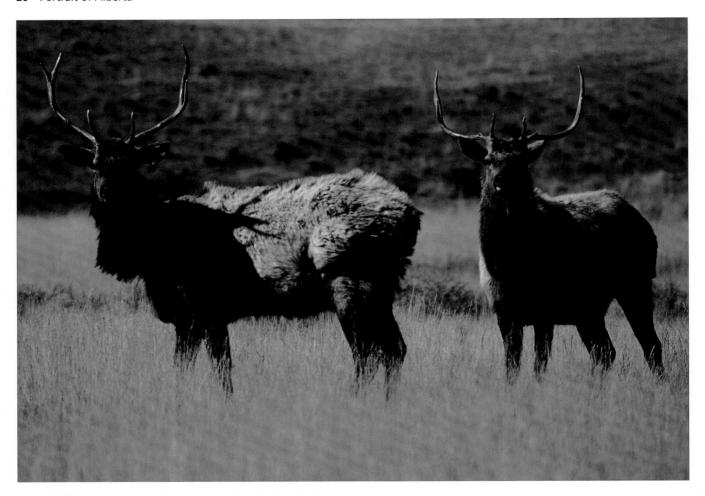

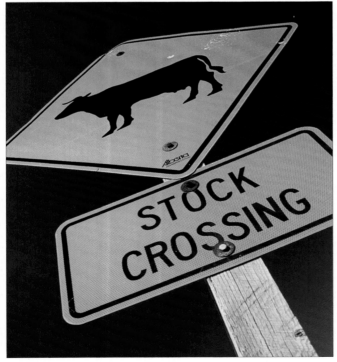

Top: A pair of wild male elk gaze at the camera. Elk are commonly seen in Alberta. They are also increasingly being ranched for their lean, tasty meat and for the velvet from their antlers, which is used in traditional Chinese medicine.

Bottom: A common road sign in ranching country.

Opposite: Wildflowers take over a field in front of an old farm building near Okotoks.

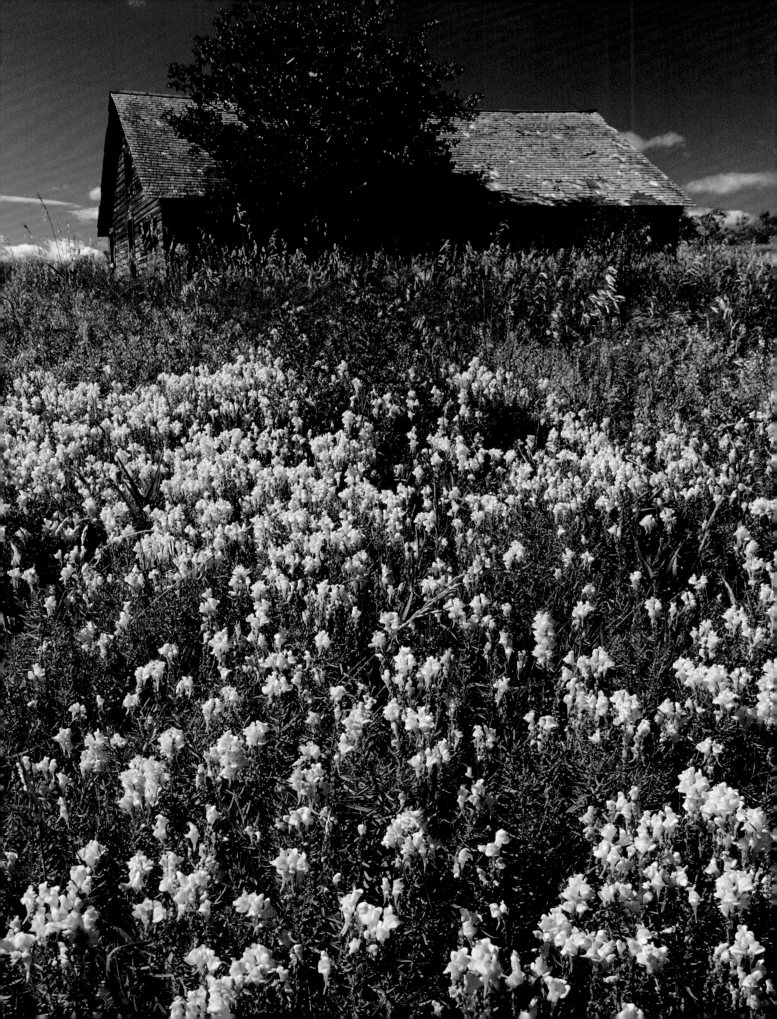

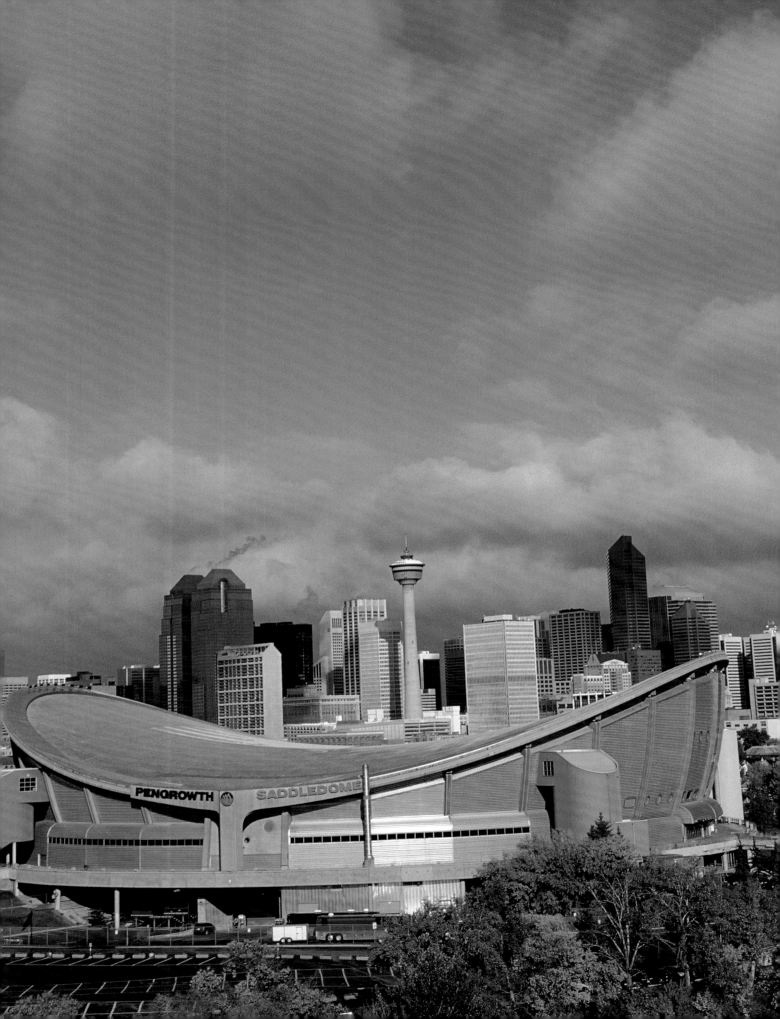

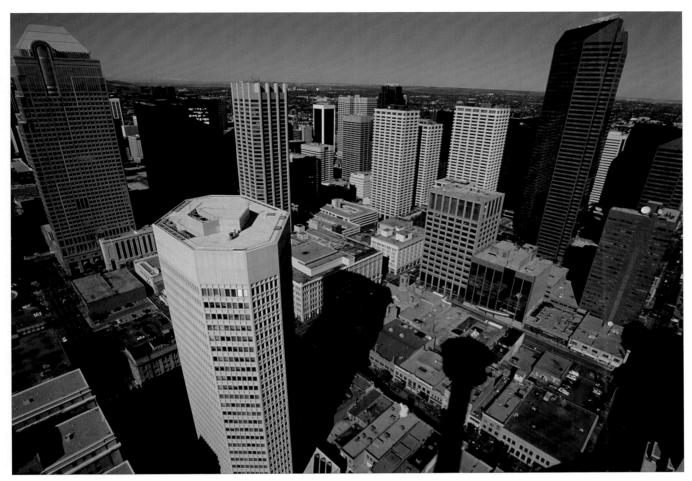

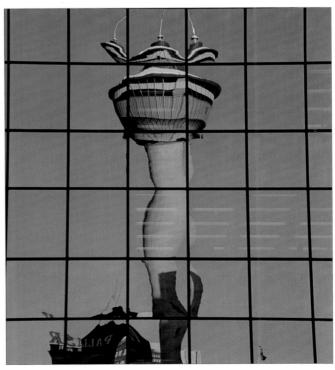

Opposite: The Pengrowth Saddledome (named for a local energy trust) is a landmark of downtown Calgary. A former Olympic venue for hockey and figure skating, the 17,000 seat arena now hosts musical events and hockey for the city's devoted fans. Its distinctive shape is a nod to Calgary's cowboy heritage.

Top: Downtown Calgary has been growing skyward almost constantly since the oil boom began in the 1970s. Despite the city's nickname of "Cowtown," its economy is somewhat dependent on oil and gas, but is diversifying more every year into services and manufacturing.

Bottom: The Calgary Tower is reflected in the shining glass of a neighbouring office building. The tower — then called the Husky Tower — was built in 1968 and immediately became a city landmark. Today, it is one of the busiest tourist attractions in Calgary for its panoramic views of city, foothills, and mountains.

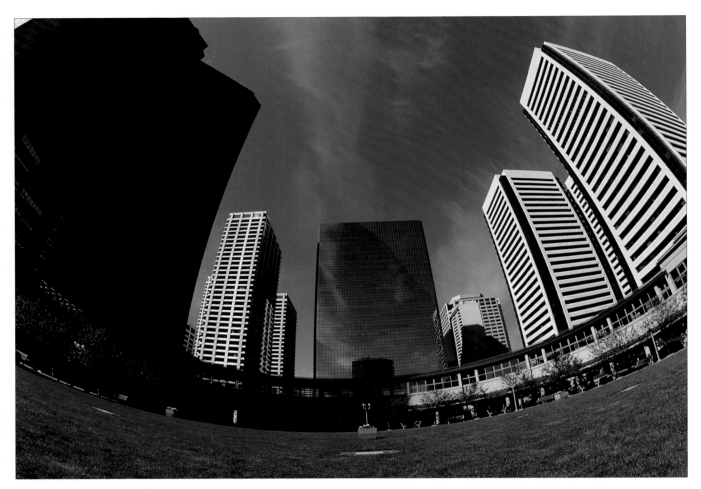

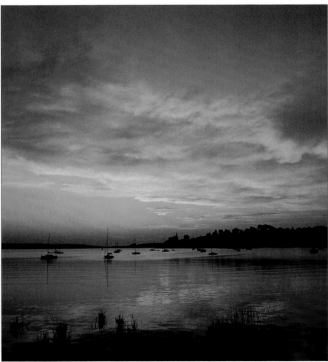

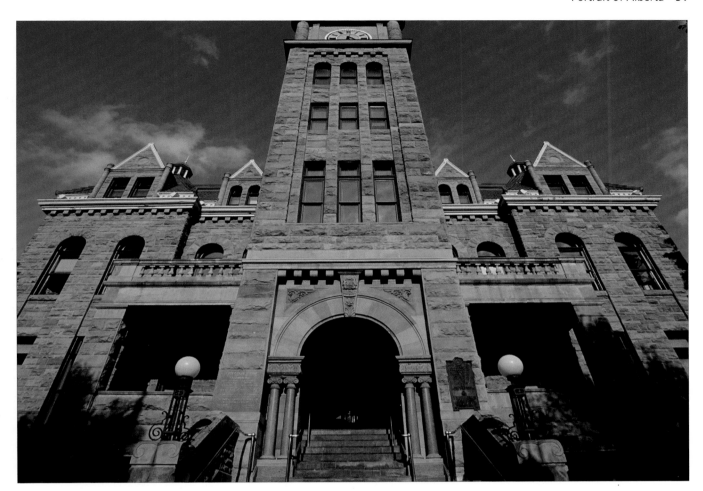

Shiny office towers and intensely blue skies are a hallmark of downtown Calgary **(opposite top left and bottom right)**.

Opposite bottom left: The intricate mosaic on the ceiling of the temple in the Calgary Chinese Cultural Centre evokes the Hall of Prayers in Beijing's Temple of Heaven.

Opposite bottom right: Tranquil sailboats on the Glenmore Reservoir at sunset.

Top: Completed in 1911, Calgary's City Hall is one of the older buildings in this still very young city.

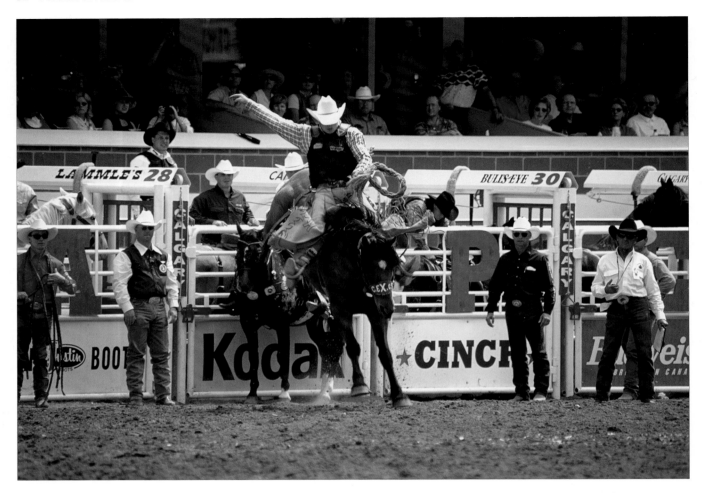

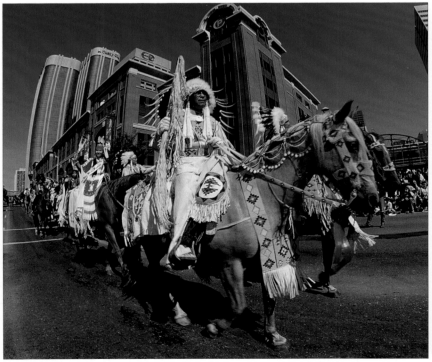

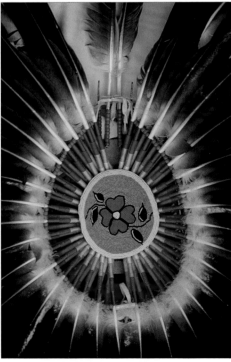

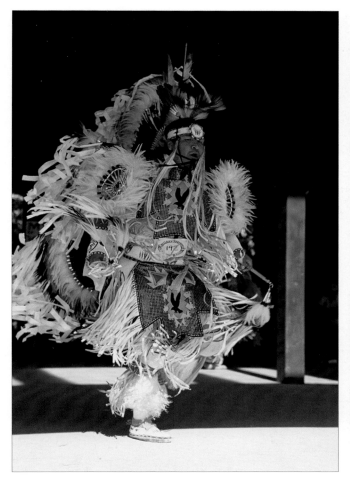

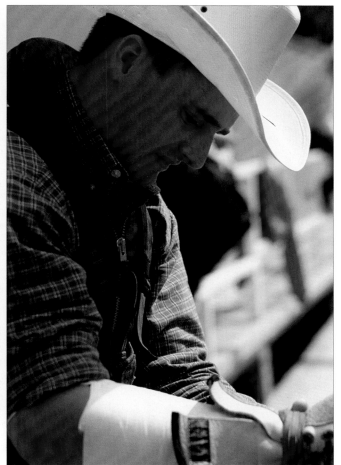

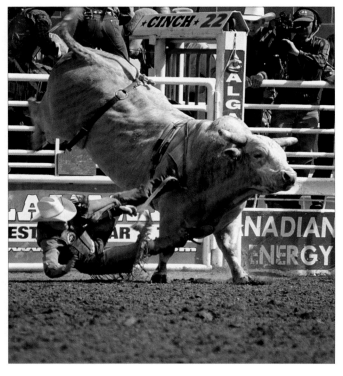

Opposite top: The Calgary Stampede is the city's most-beloved event: ten days of midway rides, pancake breakfasts, and general western mayhem. The rodeo, with saddle bronc riding, bull riding, calf roping, and chuck-wagon races, is a popular evening event.

Opposite bottom left: Natives on horses add colour and tradition to the Stampede Parade.

Opposite bottom right: Detail of a native costume.

Top left: Powwow dance competitions are a big part of the activities in the Indian Village, which has been part of the Calgary Stampede from the very beginning.

Top right: A pensive moment for a rodeo competitor.

Bottom: Bull riding is perhaps the toughest rodeo sport there is, requiring outstanding balance and strength — and the reflexes to get out of the bull's way when thrown. Eight seconds is a very long time when you're holding on with one hand to an enraged animal that weighs ten times what you do.

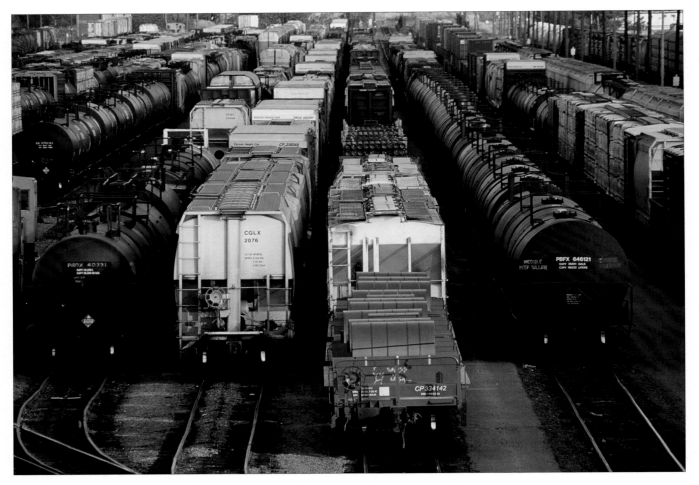

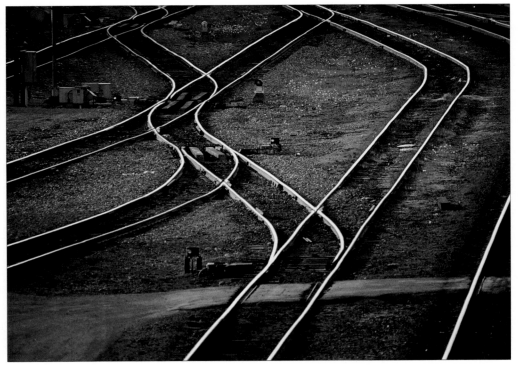

Top: Train cars of all descriptions line the tracks at the Alyth rail marshalling yards in downtown Calgary. The Canadian Pacific Railway had an enormous impact on the city's prosperity in the early days — its presence linked Calgary and its exports to the much larger markets back east, and brought waves of settlers to the new city. Today there is no public passenger rail service in southern Alberta, but plenty of freight still passes through every day.

Bottom: All tracks lead to Calgary, or so it would seem in this photo.

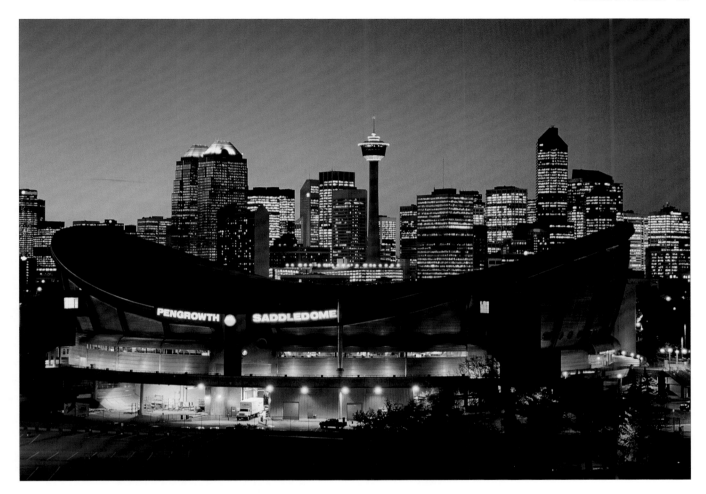

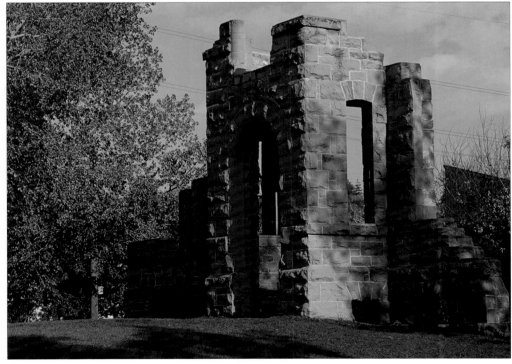

Top: Downtown Calgary and the Pengrowth Saddledome are aglow at the close of another day.

Bottom: The sandstone ruins of Calgary's first General Hospital can be found in the Victoria Park area. The hospital was completed in 1885 and served the city for several decades before eventually becoming a senior citizens' home. Demolition was begun in 1973, but a group of Calgarians lobbied to have its remains preserved.

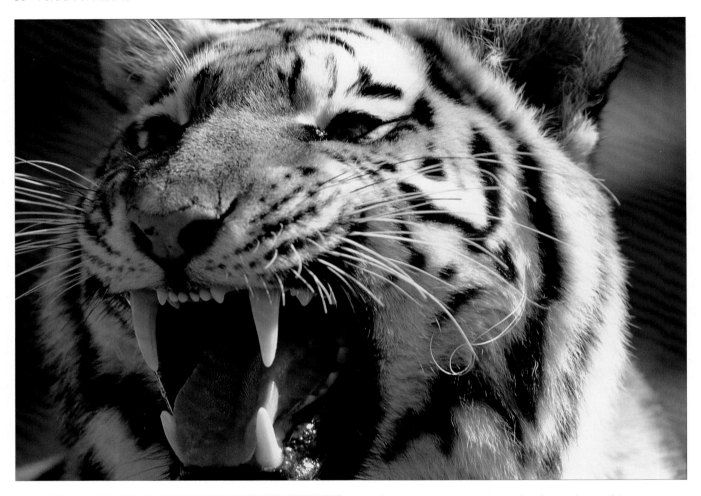

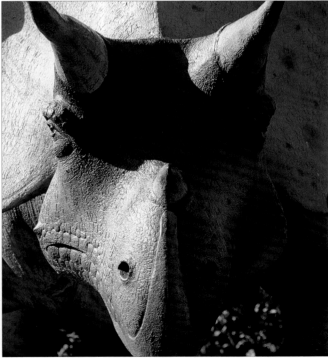

Whether it's roaring tigers **(top)** or other wild encounters you seek, the Calgary Zoo is a marvellous place to connect with nature. No other zoo in the world features both a botanical garden and a prehistoric park **(bottom)** which recreates the times when dinosaurs roamed the earth. Here you can see wolves, grizzlies, moose and bison in the Canadian Wilds area, snow leopards and elephants in Eurasia, primates of all kinds, and Creatures of the Night. Each area aims as much as possible to recreate the animals' natural habitat — no rows of cages here.

Destination Africa opened at the zoo in 2003, with giraffes, gorillas and an incredible underwater view of hippos. Vivid plants and flowers are scattered throughout the park, and the Dorothy Harvie Gardens are an attraction unto themselves.

The zoo hosts special events throughout the year, but even on an ordinary day it is a fascinating place to visit.

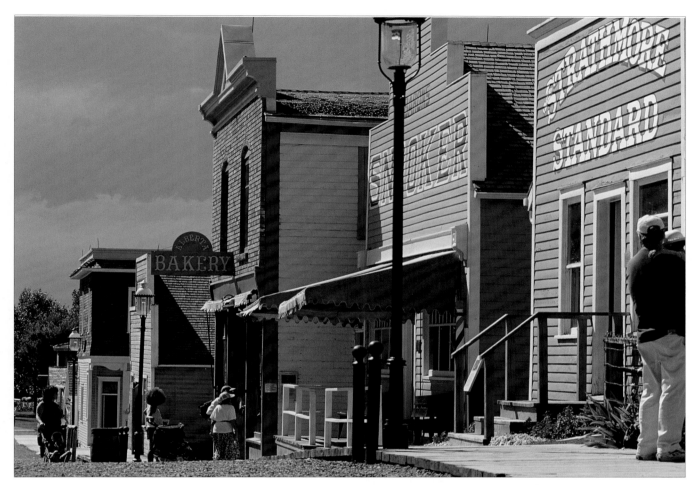

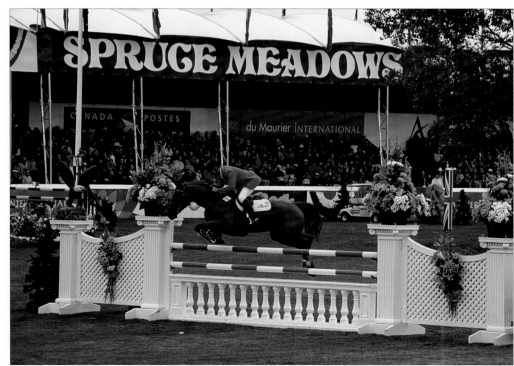

Top: At Heritage Park, visitors can get a glimpse of the West in the years between 1864 and 1914. Costumed interpreters demonstrate what life was like in pioneer days. Take a trip on the S.S. *Moyie*, a replica sternwheeler. A steam train also circles the grounds. Pictured here is the Main Street area.

Bottom: Show jumping at Spruce Meadows is always exciting to watch. The world-renowned facility is located in the foothills outside Calgary. Over 25 events, including three major international tournaments, are held here every year.

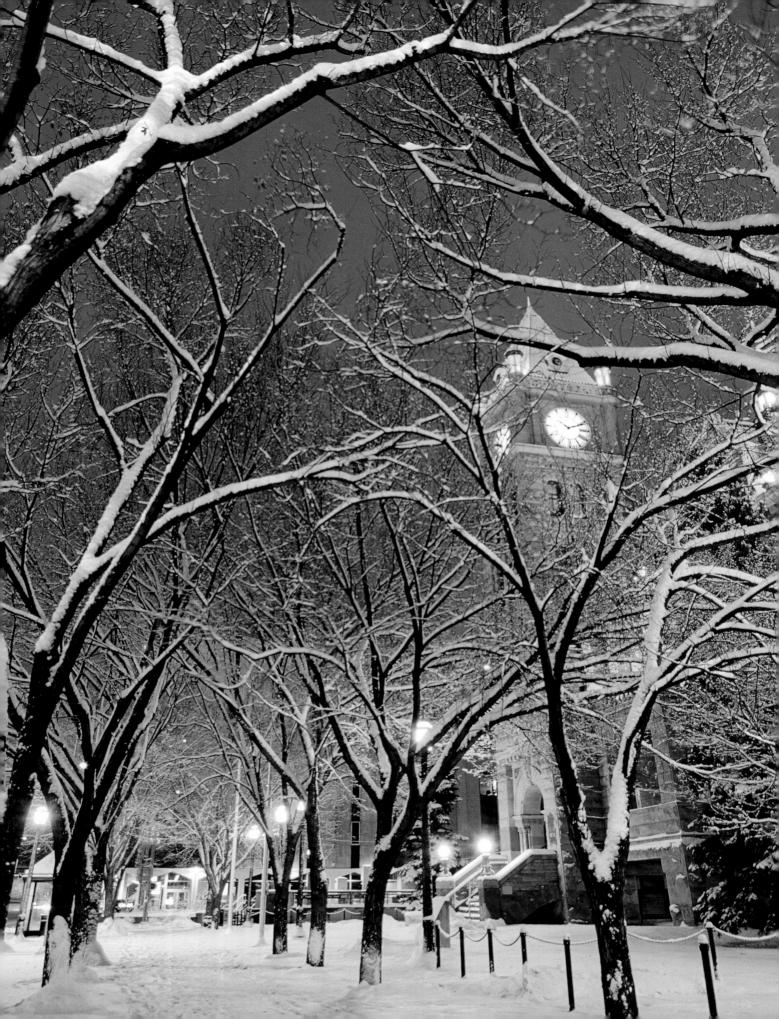

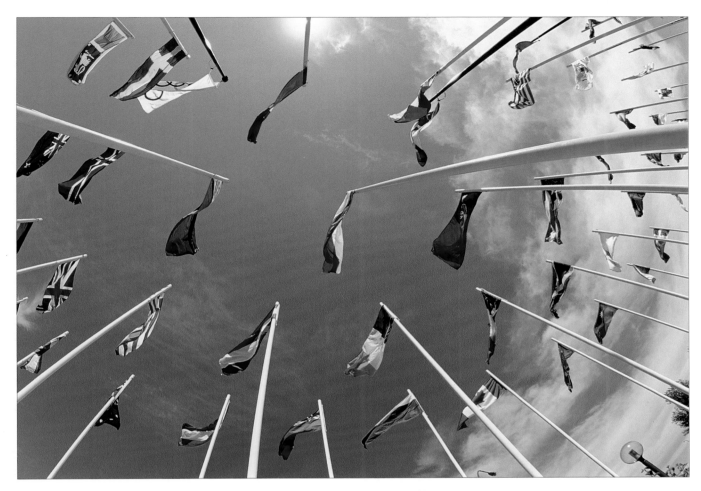

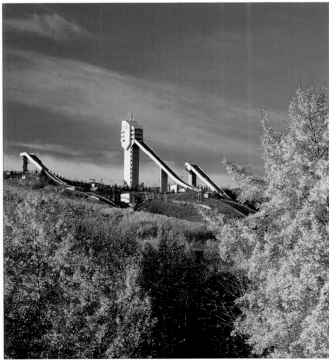

Opposite: Calgary's City Hall is radiant on a snowy winter's evening. This fine sandstone building is a Provincial Historic Resource.

Top: Every flag at Canada Olympic Park represents a country that participated in the XV Olympic Winter Games in Calgary. Events held here in 1988 were ski jumping, bobsleigh (this was the year of the famous Jamaican bobsleigh team), luge, and freestyle skiing.

Bottom: Today, Canada Olympic Park is used year-round as a training facility for events such as bobsleigh, luge, ski jumping, and skeleton. In fall, when this photo was taken, mountain biking is the main sport taking place here. Once the snow flies, Calgarians enjoy skiing and snowboarding here, only minutes from downtown.

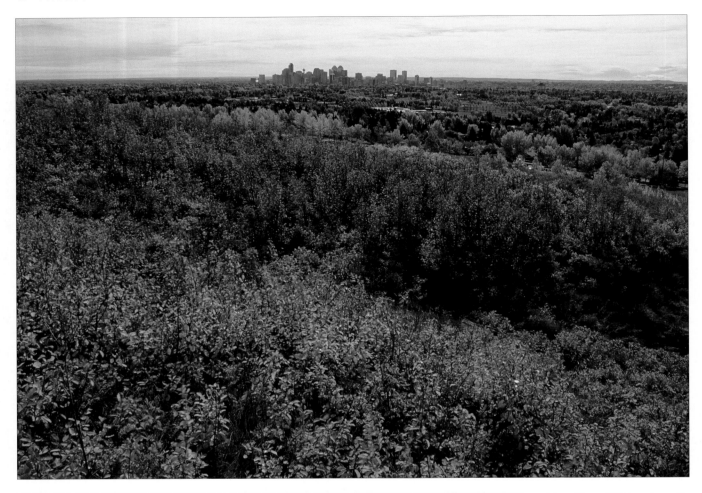

Top: Nose Hill is a beautiful place in any season: fall offers the changing colours of over 100 species trees, shrubs, native prairie grasses and wildflowers. The buffalo who used to roam here have been gone over a century, but today the park is still home to coyotes, deer and hares. Calgarians cherish this protected sanctuary almost in the heart of the ever-growing city.

Bottom: Aspen trees just before they burst into their fall brilliance.

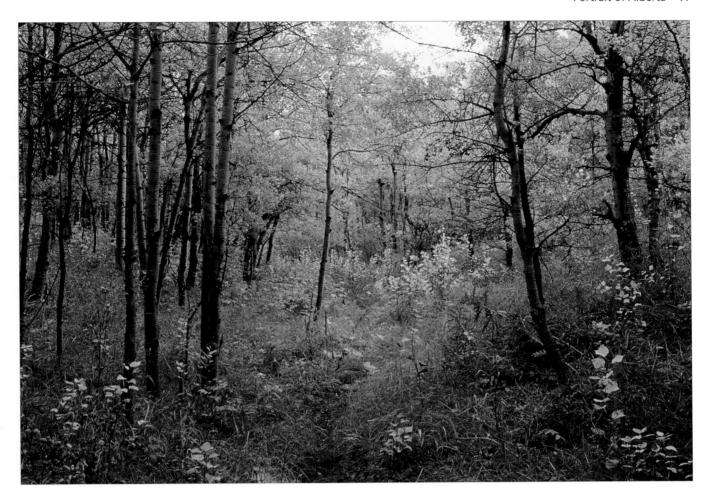

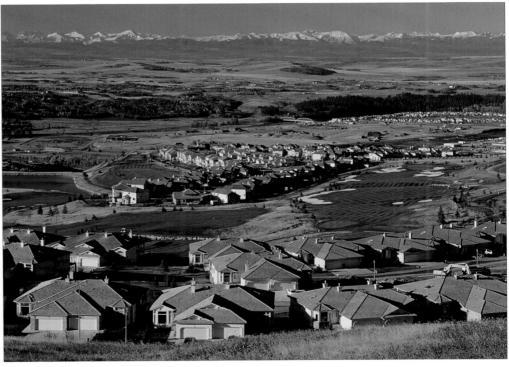

Top: Though Alberta may lack the fiery reds and oranges of an eastern autumn, its aspen trees are still spectacular in their fall finery.

Bottom: Cochrane is one of the fastest growing towns in Canada. It is ideally situated close to Calgary, with a sweeping view of the Rocky Mountains. Its ranching history comes to life downtown, where its wide main street has plenty of wooden buildings that now house funky shops and places for sweet treats. Pictured here are GlenEagles golf course and the houses that surround it.

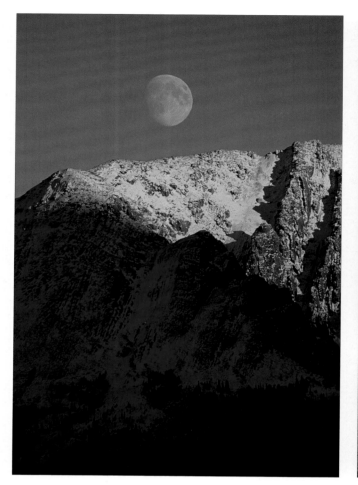

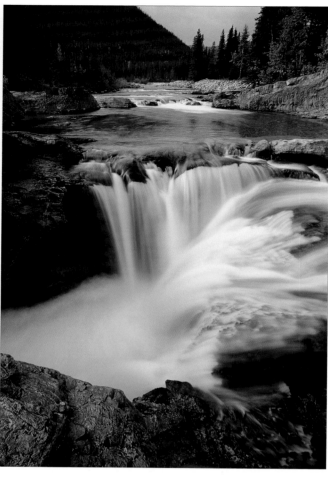

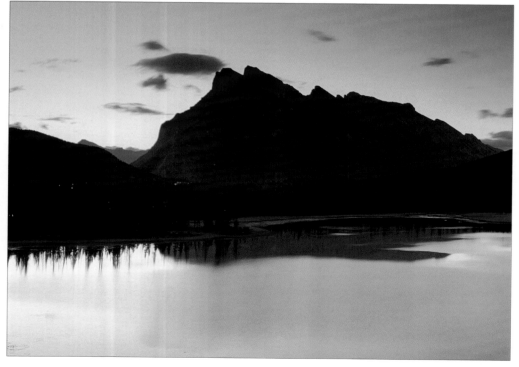

Top left: The moon over Alberta's Rocky Mountains, Banff National Park.

Top right: This pretty waterfall is Elbow Falls, found near Bragg Creek. A short trail leads to three viewpoints of the falls.

Bottom: The sky lights up above Mount Rundle and Vermilion Lakes in Banff on a summer sunrise.

Opposite: The Fairmont Banff Springs Hotel is aptly nicknamed "the Castle in the Rockies." Perched above Bow Falls, the hotel has offered travellers luxurious accommodations for over a century.

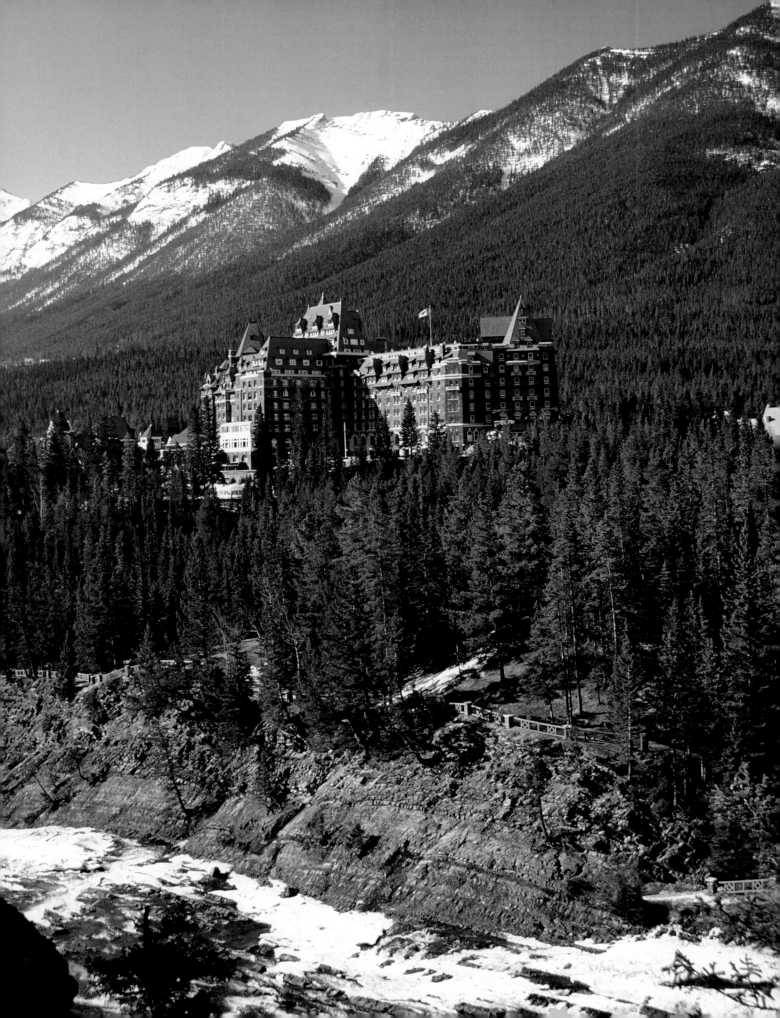

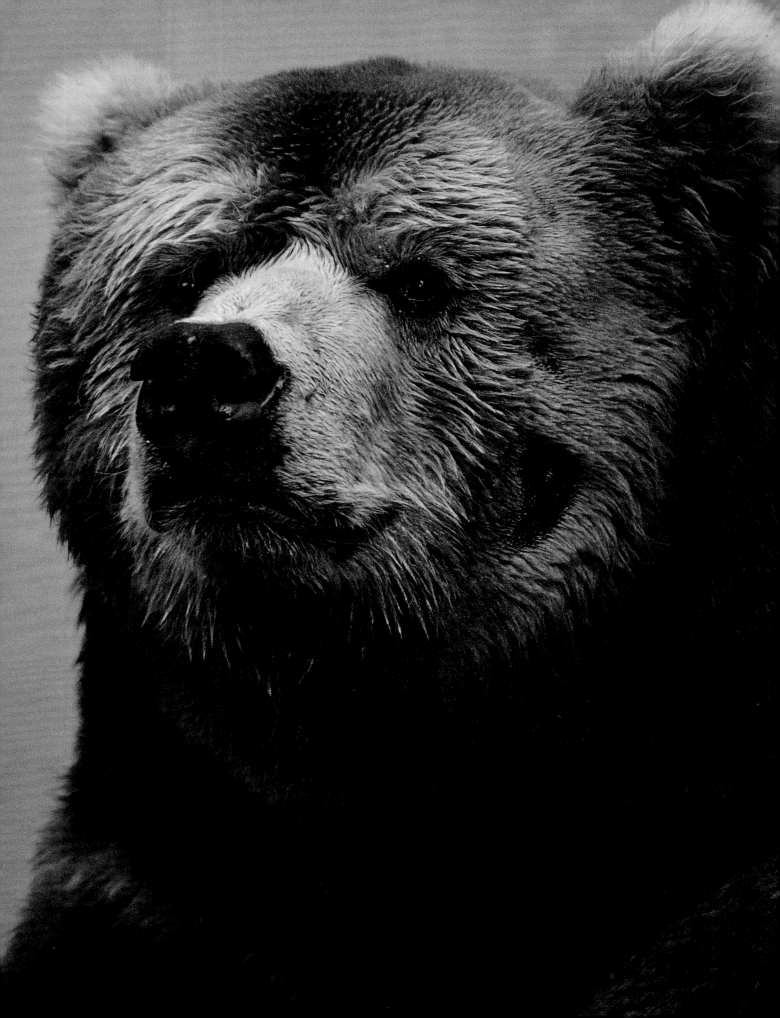

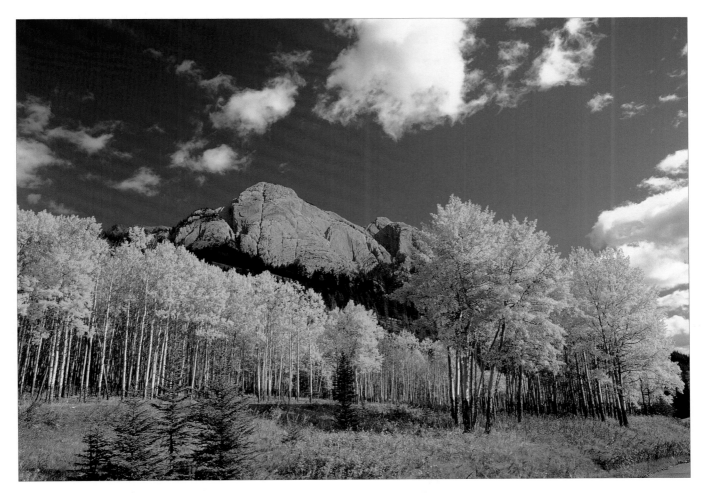

Opposite: A bear sighting is often the highlight of a visit to the Canadian Rockies, stirring the soul with a primeval connection to nature. Both black and grizzly bears live here, ranging the valleys in search of food throughout the spring, summer and fall.

Top: Is autumn the prettiest season in the Rockies? When the dazzling golden tones of aspen trees are paired with deep blue skies, this assertion is hard to argue.

Bottom: The lower falls at Johnston Canyon. This photogenic waterfall is reached by a 1.1 km walk along and atop the canyon walls.

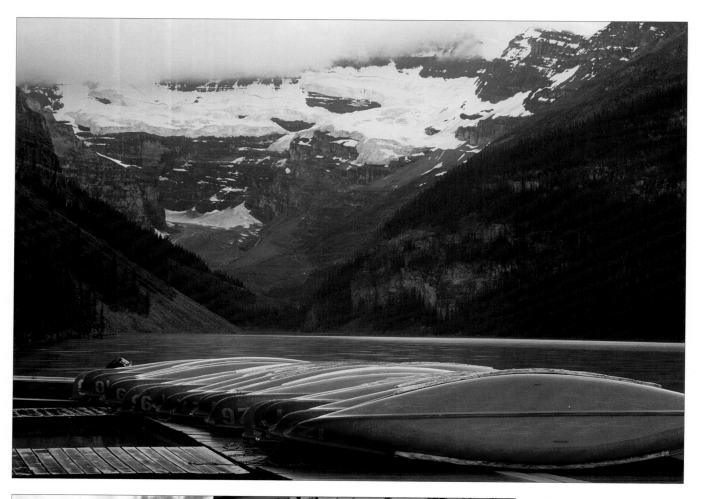

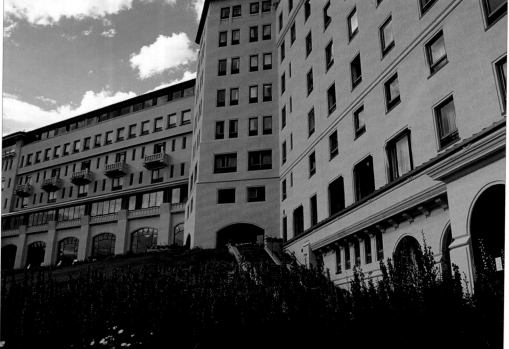

Top: A row of canoes sits outside the boathouse at world-famous Lake Louise. Even on a cloudy day, the lake — with its backdrop of the Victoria Glacier — is one of the most magnificent sights in the Canadian Rockies.

Bottom: The Fairmont Chateau Lake Louise has an unrivalled setting on the shores of the fabled turquoise lake. Its concourse is open to visitors for shopping and dining, but the upper floors are reserved for those lucky enough to be staying there. Sunrise over Lake Louise is a compelling reason to stay here.

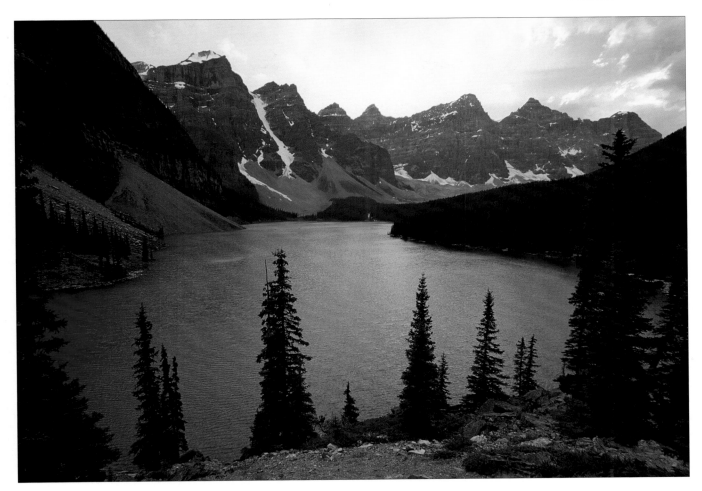

Top: Moraine Lake has an astonishing hue in summer months, when the glacial silt suspended in the water catches the sun's rays and reflects every shade and tone of blue. Most people can't believe photos of the lake are real until they see it for themselves.

Bottom: Peyto Lake, near Bow Summit, is one of the most visited stops along the spectacular Icefields Parkway that connects Banff and Jasper. A special viewing platform has been built for visitors to marvel at the lake's icy cerulean colour.

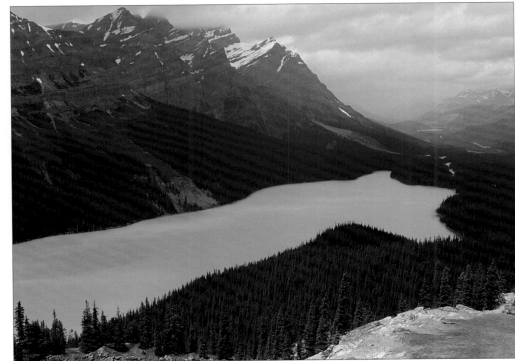

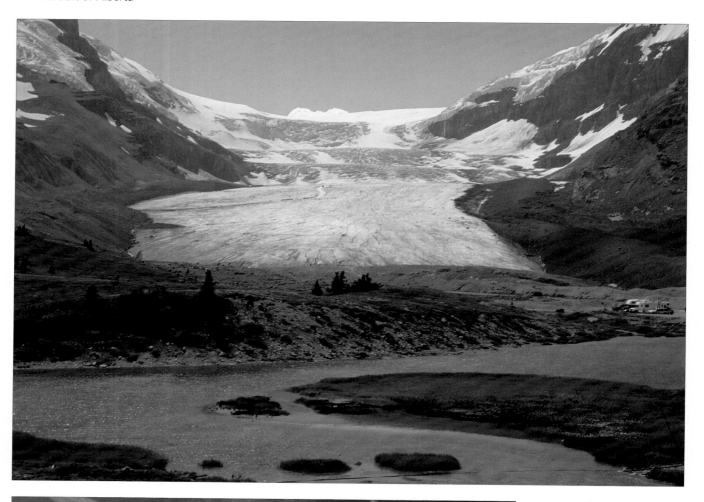

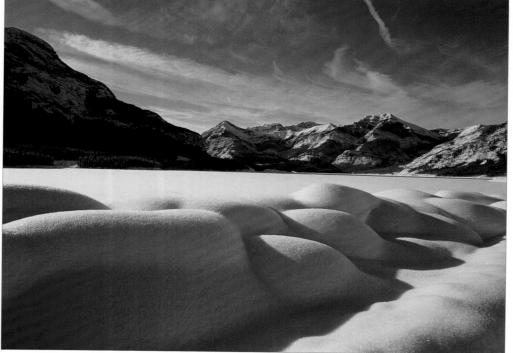

Top: The tongue of the enormous Athabasca Glacier dwarfs the Icefield Centre that faces it from across the highway. The glacier is part of the Columbia Icefield, an area of 325 km² perpetually covered in ice and snow that feeds rivers running to the Pacific, Atlantic and Arctic oceans.

Bottom: Fresh snow softens the outlines of boulders and mountains on a perfect winter's day.

Opposite: A mountain goat looks out quizzically from its rocky mountain perch.

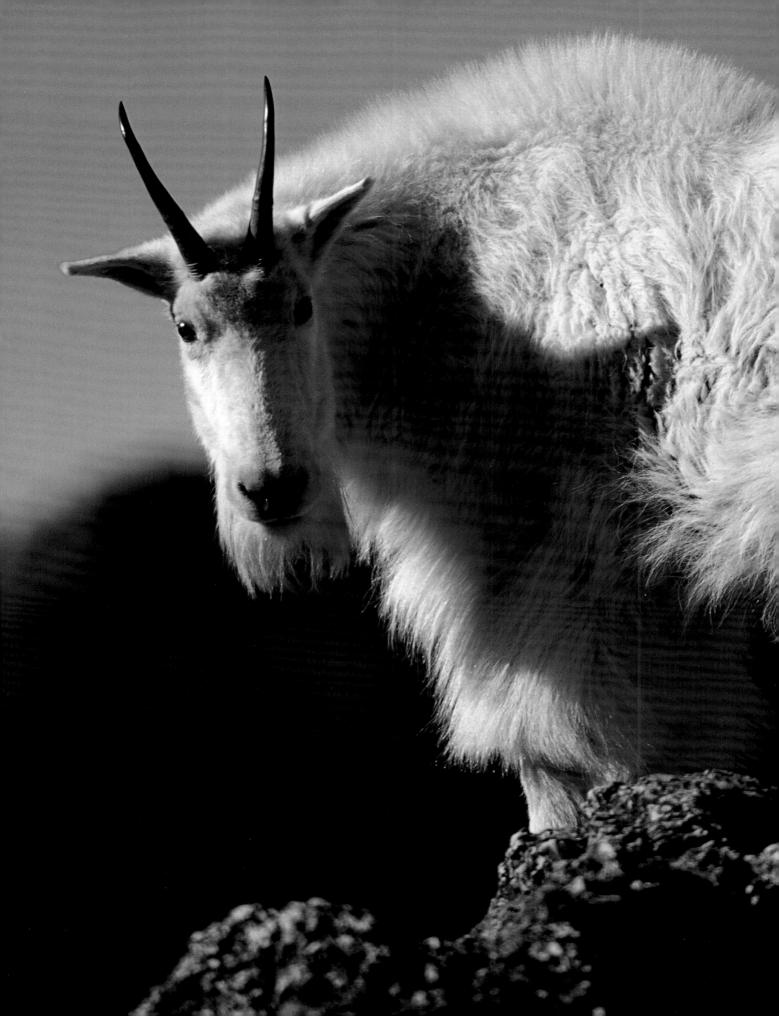

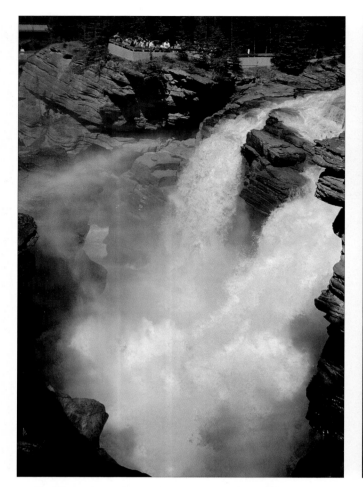

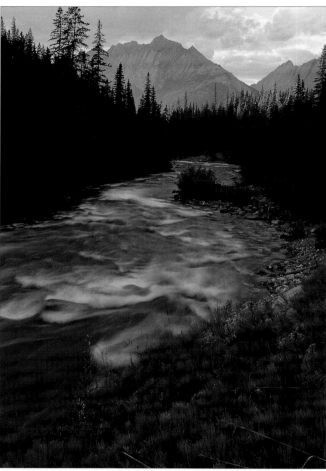

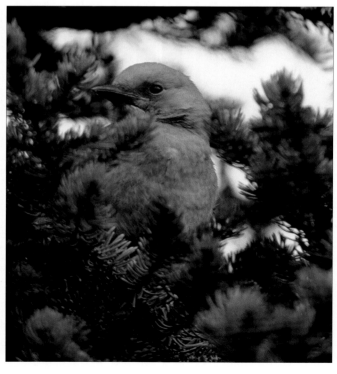

Top left: At Athabasca Falls in Jasper National Park, the silty Athabasca River — only 70 km from its glacial source at the Columbia Icefield — tumbles 23 metres through a narrow chasm carved out by the water's powerful force.

Top right: The Maligne River, near Jasper townsite, looks peaceful on a summer's evening. It's hard to believe that this calm stretch of water could be "wicked," though that is the name given the river by early French explorers in the region, probably for the impenetrable canyon on another part of the waterway.

Bottom: A Clark's nutcracker nestles in an evergreen. These bold little birds are fond of handouts and won't hesitate to help themselves if a visitor's snack looks appetizing.

Following pages: Huge fields of canola in bloom are a striking Alberta sight. Canola is one of the healthiest oils, indispensable for baking and cooking. **(Insets)** Beef and wheat are two of Alberta's major agricultural exports.

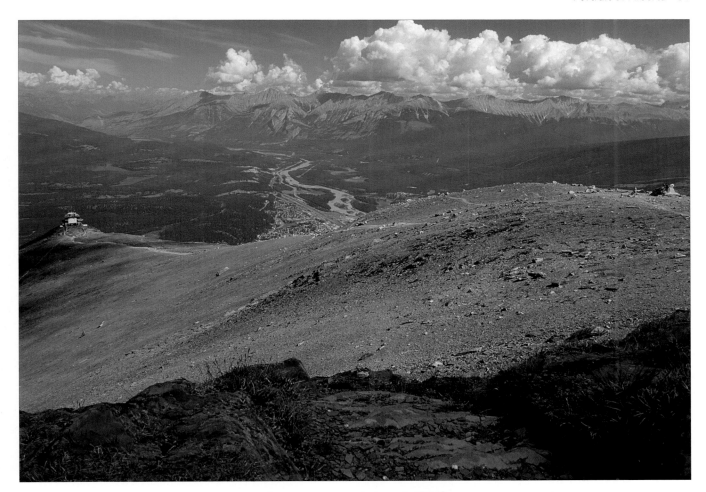

Top: From high atop Whistlers Mountain, the view of Jasper and area, including the Miette and Athabasca valleys, is exceptional. Most visitors take the Jasper Tramway to its upper terminal.

Bottom: Hoary marmots are a common sight in the Canadian Rockies. Their silvery fur allows them to blend in well with their stony surroundings, and often they are not seen until they race away from impending danger. Many of these marmots make their home in the alpine meadows of Whistlers Mountain, which is named for their piercing call.

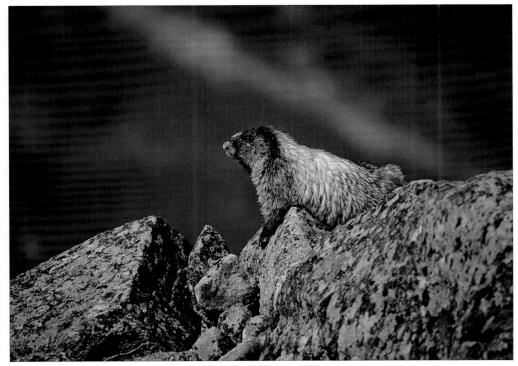

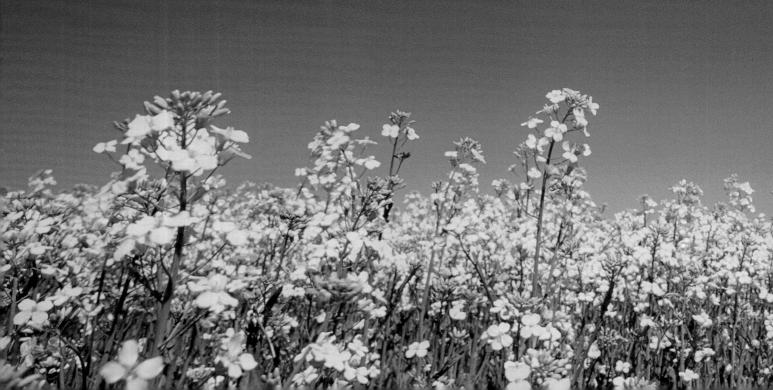

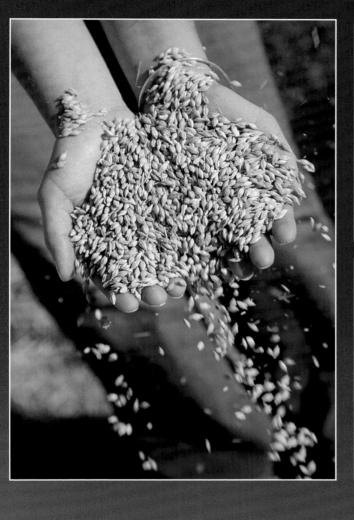
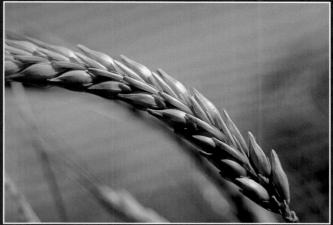

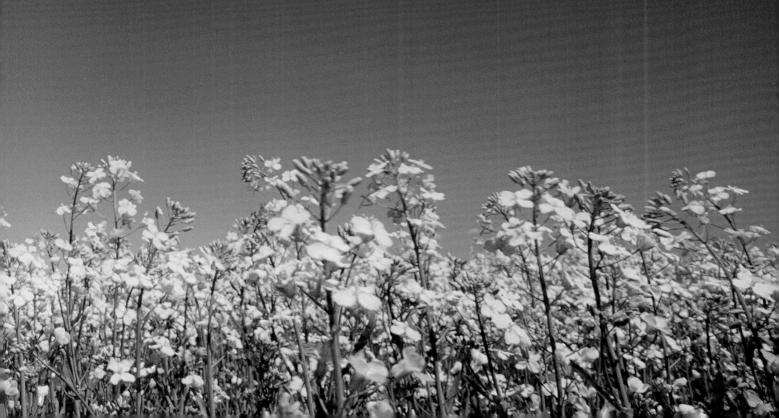

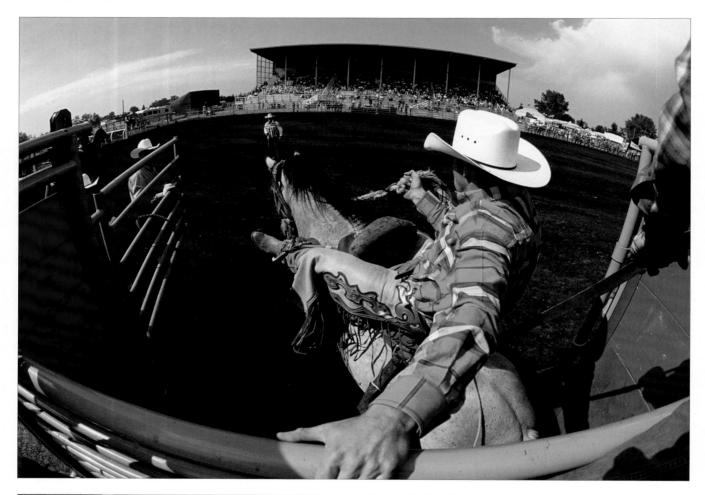

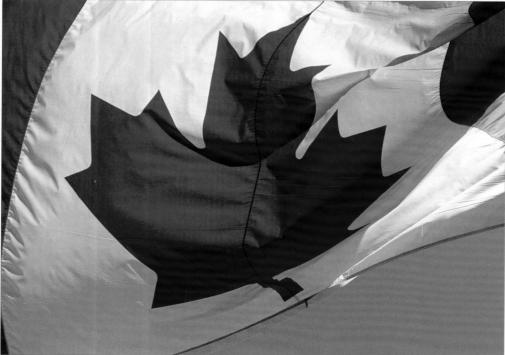

Top: Alberta's cowboy tradition lives on at dozens of small rodeos that take place around the province throughout the summer months. Here, a cowboy prepares himself for a wild ride at the Mountain View County Fair and Rodeo in Olds.

Bottom: The maple leaf is a proud Canadian symbol that "represents all the citizens of Canada without distinction of race, language, belief or opinion."

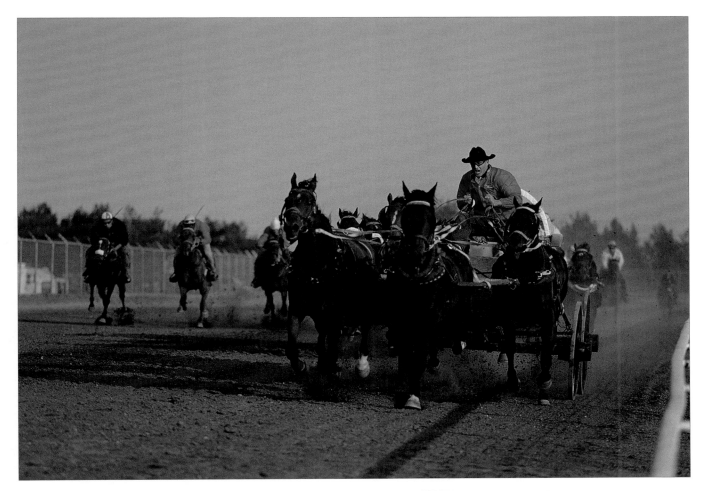

Top: The first official chuckwagon race was held at the Calgary Stampede in 1923, and the event has been thrilling rodeo fans ever since. Here, at the Strathmore rodeo, you can almost taste the dust in your mouth as the four thoroughbreds and driver race past, trailed by the outriders who make up the rest of the team.

Bottom: The abandoned Catholic church sits forlornly in the tiny hamlet of Dorothy, one of Alberta's ghost towns

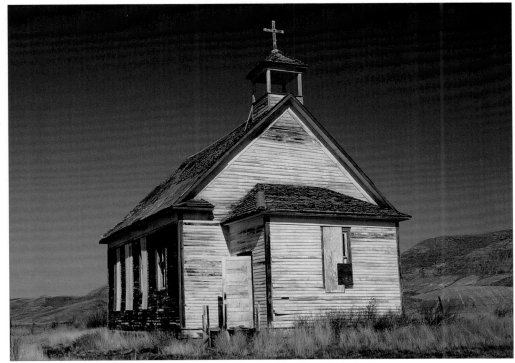

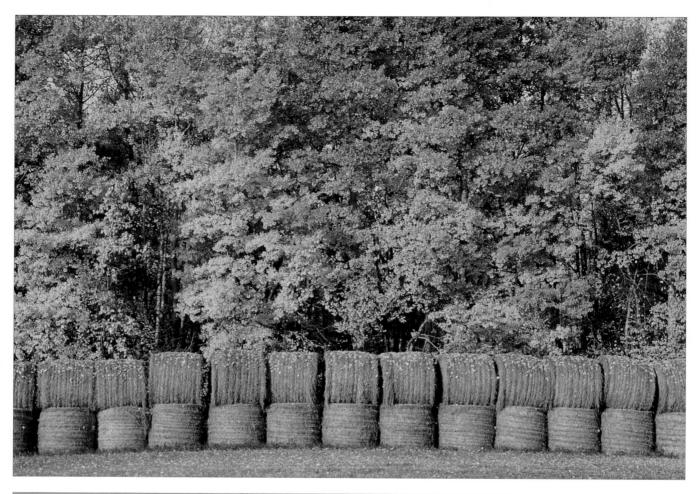

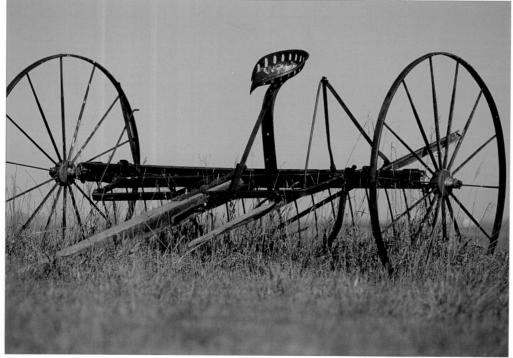

Top: A pleasing row of hay bales against autumn leaves.

Bottom: This old hay rake was designed to be pulled by a team of horses, with the farm boy sitting in the seat and directing the horse where to deposit the hay. Now it sits in a field while newer machines do its work.

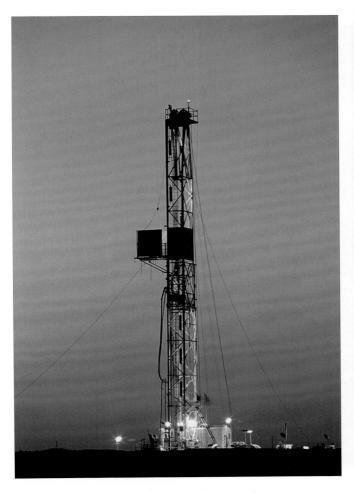

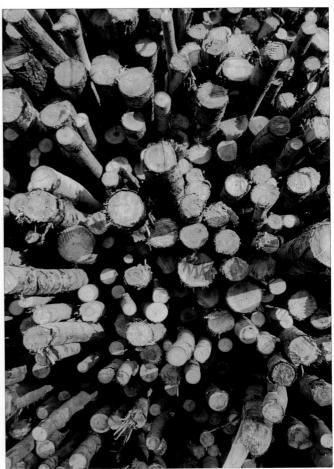

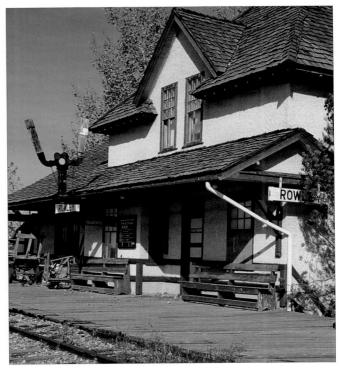

Top left: A drilling rig is lit up against an Alberta sunset. Oil is one of Alberta's most lucrative exports.

Top right: Log piles are more than former trees — they're a strong economic driver. Almost 60% of Alberta is forest, which contributes to a healthy provincial lumber industry. The industry supports employment for over 50,000 people.

Bottom: The train station at Rowley, near Drumheller. Only a handful of permanent residents still live here, making it a candidate for ghost town status, but many of the old buildings are still in good repair. The station, which was built in 1923, has been turned into a railway museum.

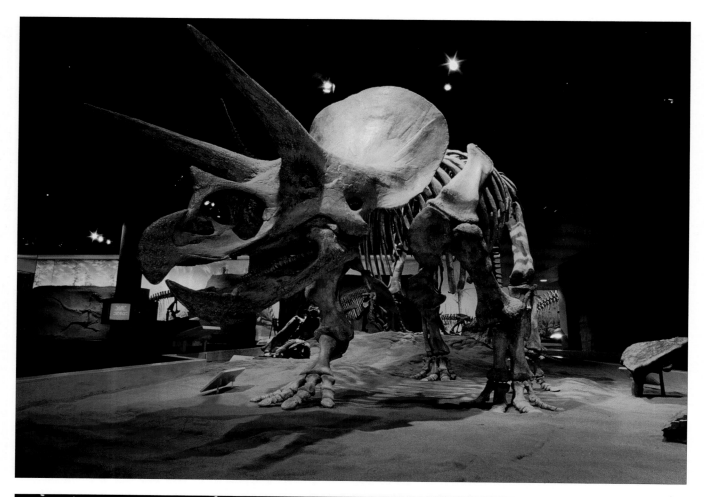

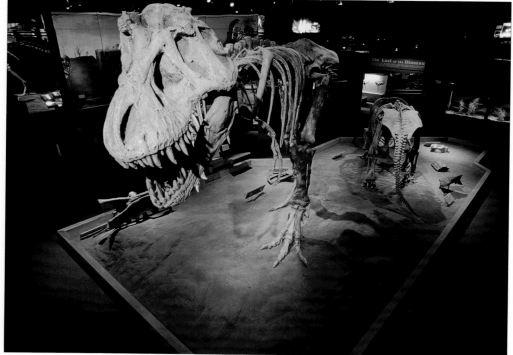

Top: A triceratops skeleton looms large in the Tyrrell Museum of Paleontology in Drumheller. The museum is renowned for its research into dinosaurs and for its outstanding exhibits that bring the long-distant past of the dinosaurs to life.

Bottom: A towering Tyrannosaurus Rex skeleton at the Tyrrell.

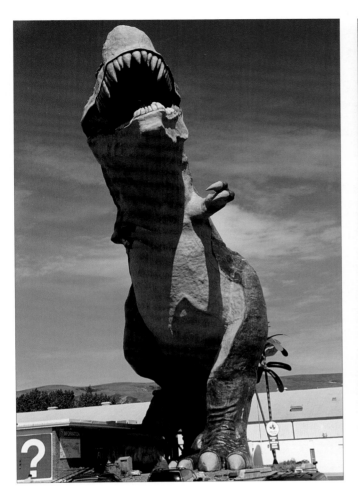

Top left: Four times larger than a real Tyrannosaurus Rex would have been, this enormous replica in Drumheller is known as the World's Largest Dinosaur. It stands 81 feet tall and features a viewing platform about seven storeys high from which visitors can see the town of Drumheller and its river valley.

Top right: The badlands around Drumheller are stark and deeply eroded.

Bottom: The Red Deer River valley broadens impressively just west of Morrin.

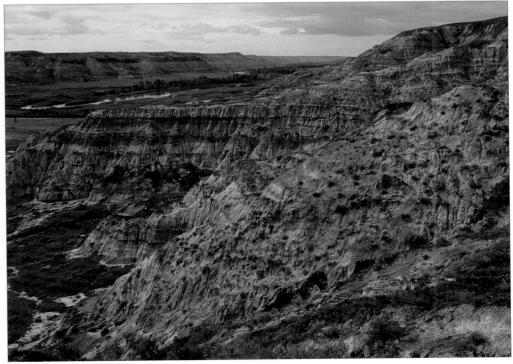

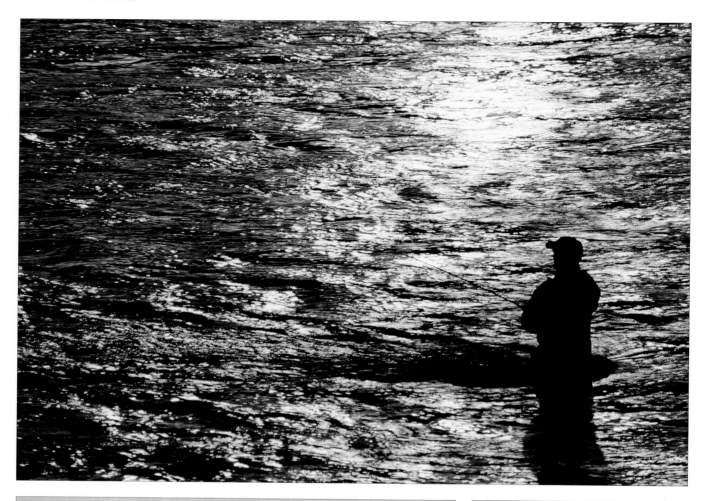

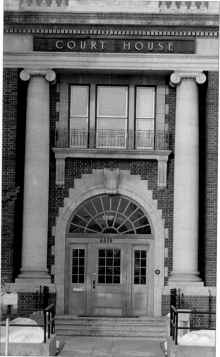

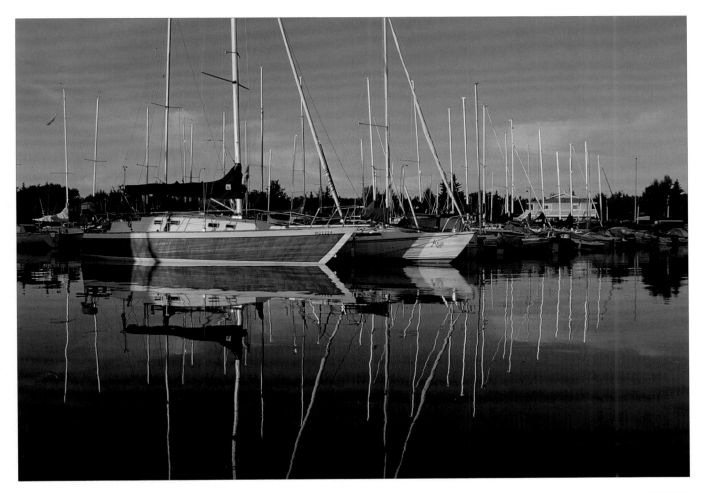

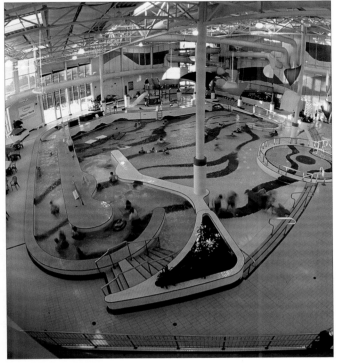

Opposite top: A fisherman enjoys a golden moment on the Red Deer River. It's an excellent river for trout fishing.

Opposite bottom left: The Collicutt Centre in Red Deer is an athletic and recreational complex that houses a leisure water park, an NHL-sized ice surface, a climbing wall, and an indoor running track, among many other amenities.

Opposite bottom right: That Red Deer's Old Court House can be named "Old" is a testament to the youthfulness of the province: this handsome building was completed in 1931. it now houses artists' workshops and studios.

Top: Sailboats at the Sylvan Lake marina. Only a few minutes' drive from Red Deer, this beach resort town is a recreational destination for many Albertans — over a million people visit every year. There's even a lighthouse to make the seaside feeling complete.

Bottom: The ENMAX Water Park is one of the busiest places within the Collicutt Centre.

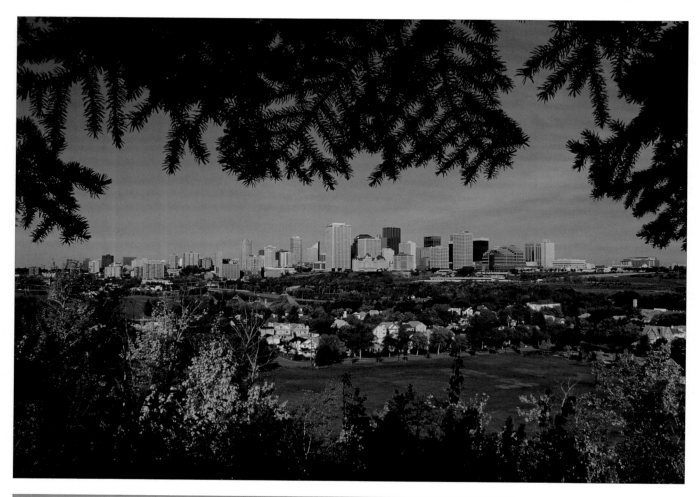

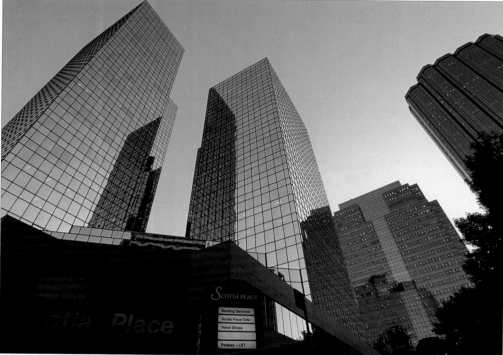

Top: Downtown Edmonton as seen from above Gallagher Park. For four days every August, the park is filled with thousands of music fans, who come to enjoy one of North America's biggest folk music festivals. In winter, the park is home to the Edmonton Ski Club.

Bottom: The twin towers of Scotia Place in downtown Edmonton reach for the sky at the end of the day.

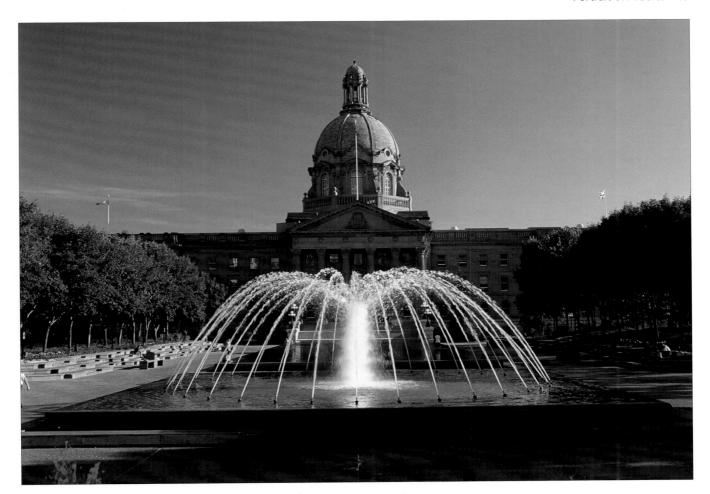

Top: Alberta's Legislature Building was officially opened in 1912 near the site of the original Fort Edmonton. Built of granite and sandstone in the Beaux-Arts style, it is one of the most striking buildings in Alberta. The fountain and reflecting pool, along with the gardens, were added much more recently. The grounds are a pleasant place to visit in any season.

Bottom: The columns of the Legislature Building are lit dramatically at night.

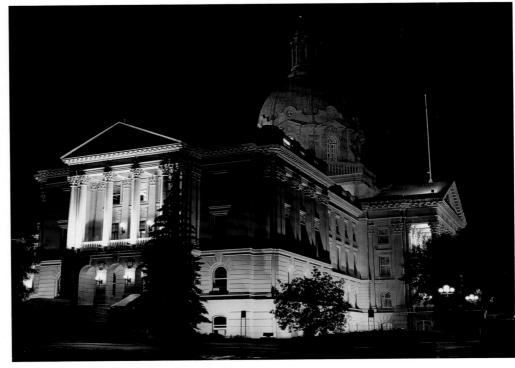

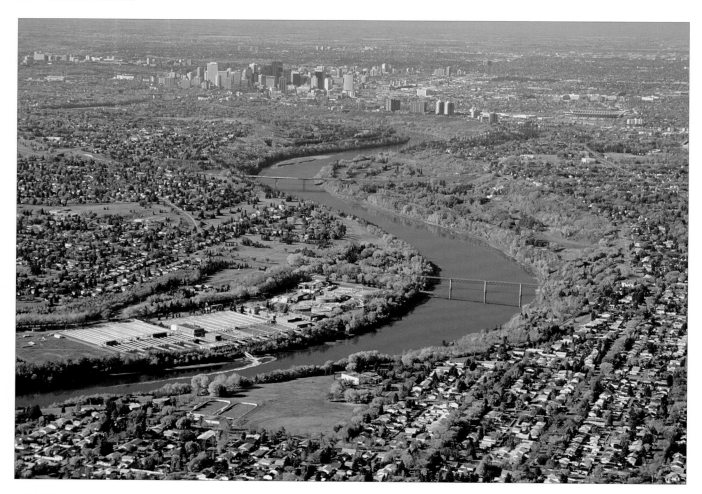

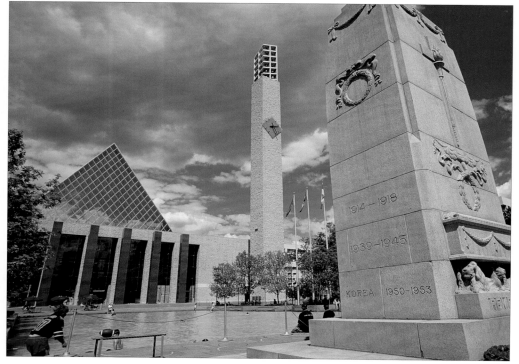

Top: The North Saskatchewan River snakes its way through Edmonton's autumn foliage. The river valley's 22 parks and connecting green spaces make it the largest urban parkland system in North America.

Bottom: Edmonton's City Hall, with its glass pyramid, was designed to evoke the mountains rising above the prairie. The reflecting and wading pool outside becomes a skating rink in the winter months. The 70-metre Friendship Tower features a 23-bell carillon that rings every hour on the hour.

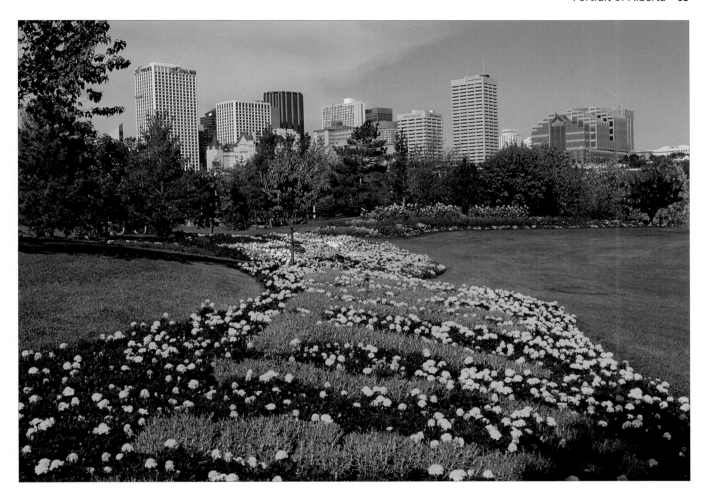

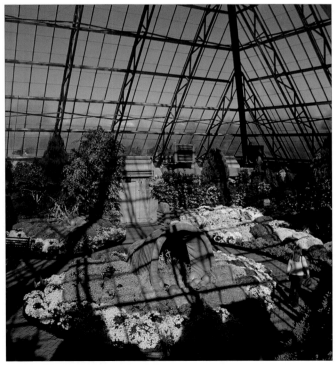

Top: Only a few minutes from the busy heart of the city, the outdoor gardens at the Muttart Conservatory offer a colourful place to enjoy nature in spring, summer and fall. Indoors, each glass pyramid houses a different garden: tropical, temperate, or arid, plus a show garden. The Muttart Conservatory is open year-round, and can be especially appreciated in the dead of winter, when outside temperatures plummet.

Bottom: The display at the Muttart's Show Pyramid changes about eight times a year to reflect the seasons. Pictured here is an autumn show of pumpkins, scarecrows, and corn.

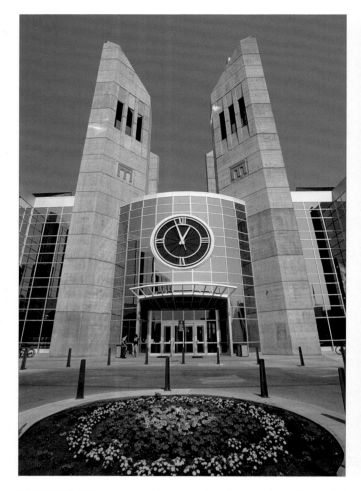

Top left: The award-winning downtown campus of Grant MacEwan Community College has filled empty former railway lands in Edmonton, bringing a new sense of vibrancy and community to the area. The campus boasts a state-of-the-art health and wellness facility.

Top right: The ornate interior of the church at the Ukrainian Cultural Heritage Village. In the early 1900s, thousands of Ukrainian immigrants came to settle in the fertile farmland northeast of Edmonton. The Village celebrates their history by recreating life in a Ukrainian settlement in the early part of the 20th century.

Bottom: Edmonton has a small but thriving Chinatown. This statue is found at the imposing Chinatown Gate at 102 Avenue and 97 Street. The gate was built as a symbol of friendship between Edmonton and Harbin, its sister city in China.

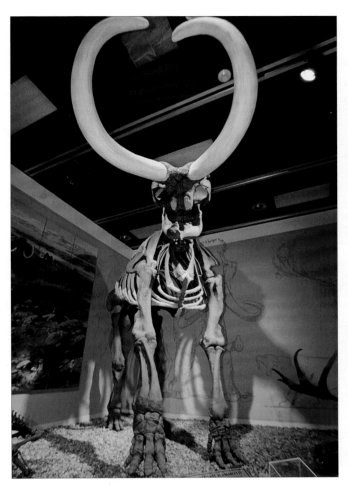

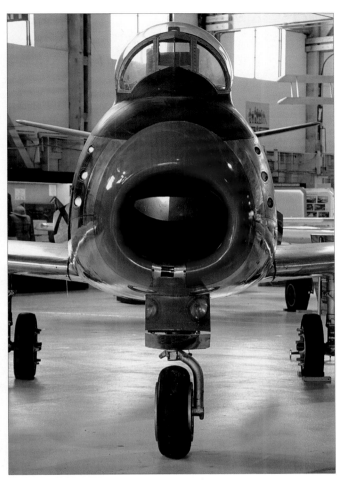

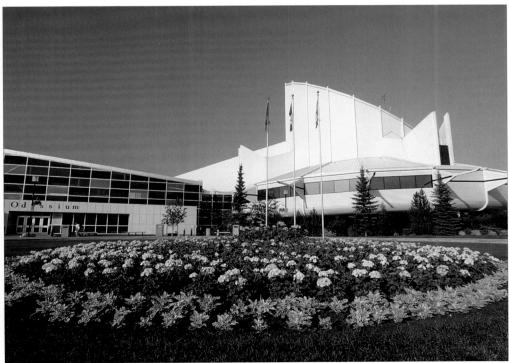

Top left: An imposing mammoth skeleton dominates the fossil display in the Natural History Gallery at the Provincial Museum of Alberta.

Top right: At Edmonton's City Centre Airport, the Alberta Aviation Museum displays a number of restored and replica aircraft, including this Canadair CF-86 Sabre fighter bomber.

Bottom: The Odyssium is a hands-on museum that teaches kids (and grownups!) about the wonders of the universe, from space travel to the complexities of the human body.

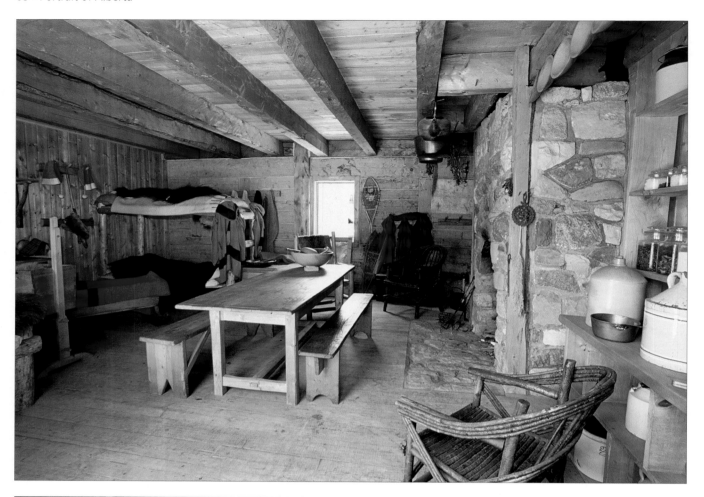

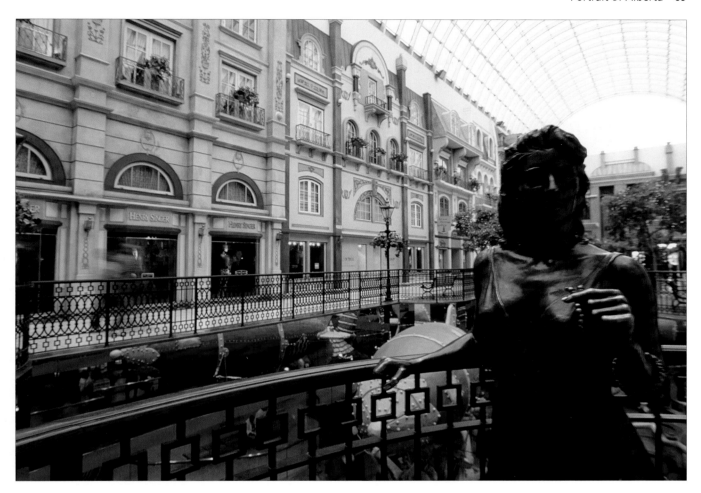

Opposite top: The history of Edmonton is brought to life at Fort Edmonton Park in the river valley.

Opposite bottom: Edmonton is the Festival City, including Klondike Days **(opposite left)** and the Heritage Festival **(opposite right)**.

The biggest draw for visitors to the city is the West Edmonton Mall, the world's largest shopping and entertainment complex. Europa Boulevard **(top)** and the World Waterpark **(bottom)** are just two of the many amazing sights at the Mall.

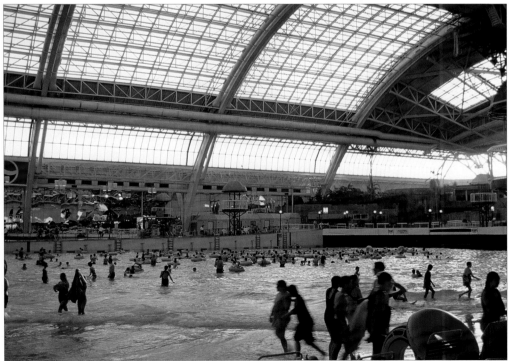

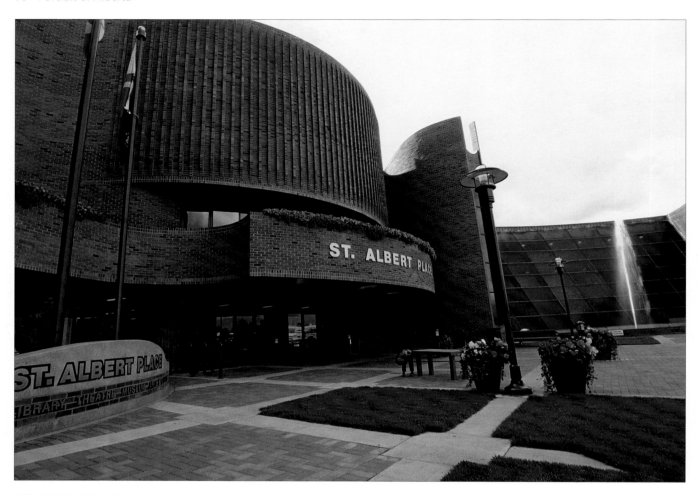

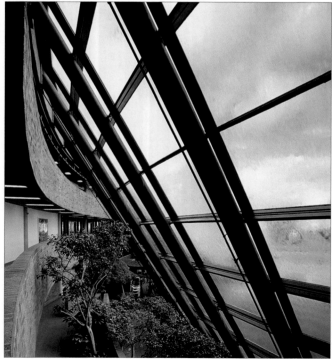

Top: Just north of Edmonton, St. Albert was originally established by Catholic missionaries. St. Albert Place, designed by Douglas J. Cardinal, is home to the city council and numerous community facilities.

Bottom: The interior of St. Albert Place.

Opposite top: The setting sun warms an otherwise chilly scene of snow on frozen Lac La Biche, north of Edmonton.

Opposite bottom left: Painting colourful wooden eggs is a beloved Ukrainian folk art. Each egg is decorated with symbols reflecting various good things, such as wealth, fertility, and love.

Opposite bottom right: Detail of the World's Largest Pysanka in Vegreville, which was built in the centennial year of the Royal Canadian Mounted police to symbolize the peace and security as brought by the force. This giant Ukrainian Easter egg stands over 30 feet tall.

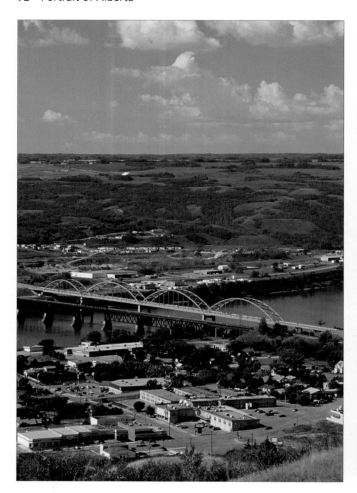

Top left: Peace River and its symmetrically arching bridge.

Top right: On the Shaftesbury Ferry, visitors can follow in the footsteps of intrepid explorer Alexander Mackenzie, who once explored this river for the North West Company. The ferry, which is pushed by a tugboat, is a scenic way to cross the Peace River.

Bottom: The Dunvegan suspension bridge crosses the Peace River valley.

Opposite page: Under a prairie sky, the Maple Leaf brightens up the landscape in Northern Alberta.

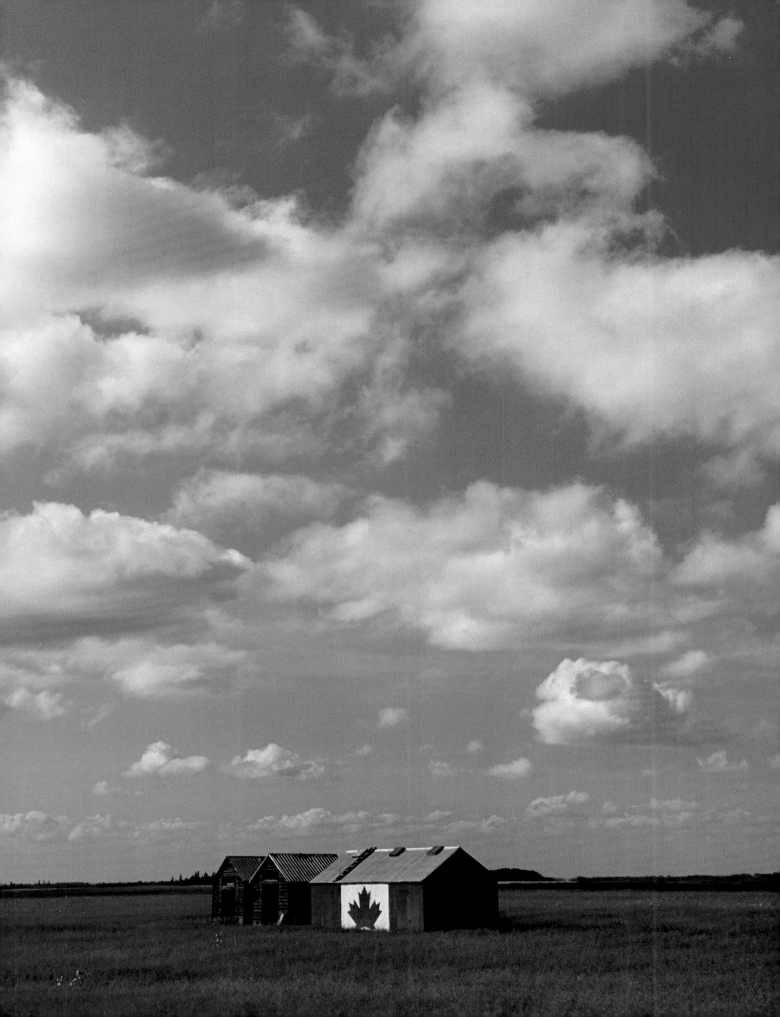

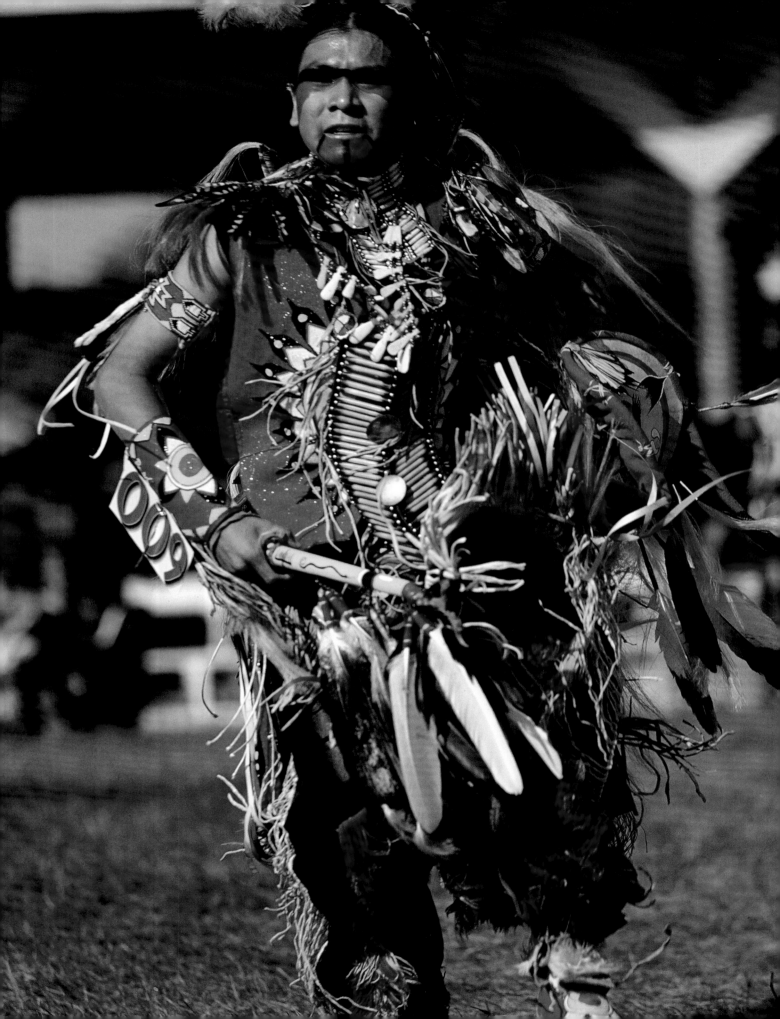

Opposite page: Powwows are held throughout the summer months in many locations in Alberta. They offer a chance for Natives to reconnect with family and friends and to enjoy traditional activities such as dancing and drumming.

Top: Drums are central to most native ceremonies, and are an integral element of traditional dances.

Bottom: Tepees were the original portable dwelling, invented by the Natives of the Great Plains. Each unique painted design has familial or clan meanings.

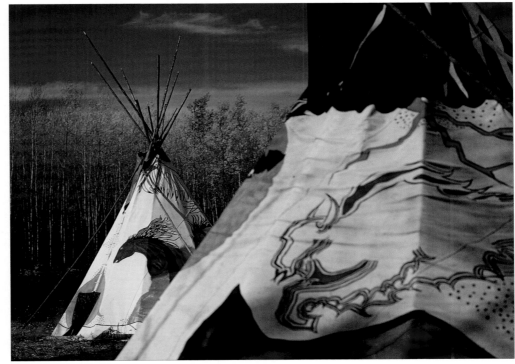

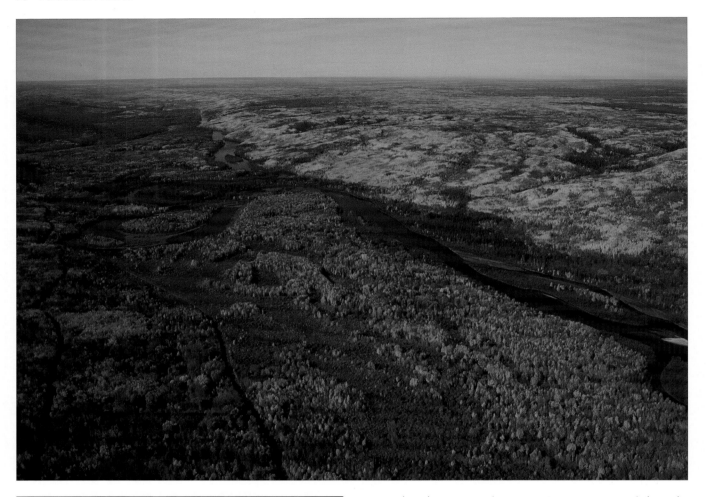

Top: The Clearwater River, near Fort McMurray, is breathtaking in its autumn splendour when seen from above.

Bottom: A northern Alberta sunset can be a magical thing to behold.

Opposite top: Downtown Fort McMurray is reflected in the windows of the Oil Can Tavern.

Opposite bottom left: These siltstone statues pay tribute to the once plentiful wood buffalo that still inhabit the region near Fort McMurray.

Opposite bottom right: Fort McMurray's Heritage Park celebrates the relatively short history of this northern boomtown. This building is St. Aidan's Anglican Church, built in 1938.

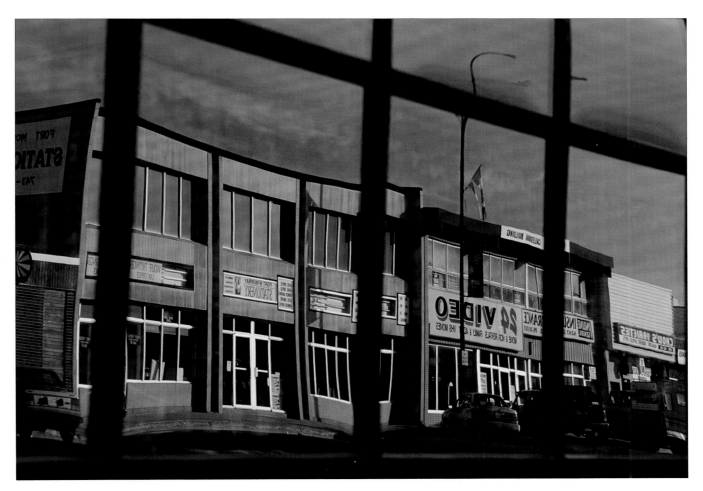

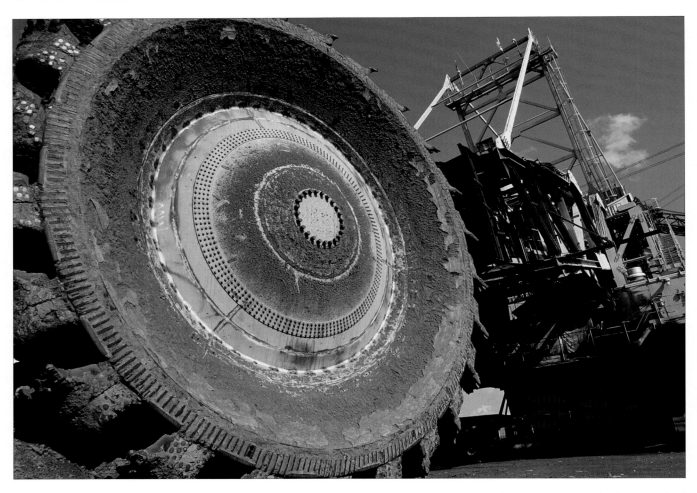

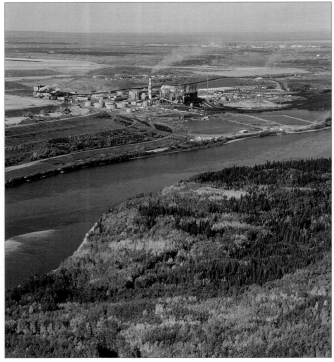

Alberta's oil sands are the largest single deposit of oil in the world…and the engine driving Fort McMurray's red-hot economy. Syncrude offers a tour of its operation that includes the Giants of Mining Exhibit **(top)** examining the origins of some of Syncrude's pioneering technology and its enormous machines. The tour continues through Syncrude's working mine area, finishing up at a viewpoint where bison are peacefully grazing on reclaimed land.

Bottom: At a site this large, it's not surprising some of the trucks used can carry up to 400 tons of oil! Pictured is Syncrude's facility on the far side of the Athabasca River. The oil sands giant produces 13% of Canada's petroleum requirements.

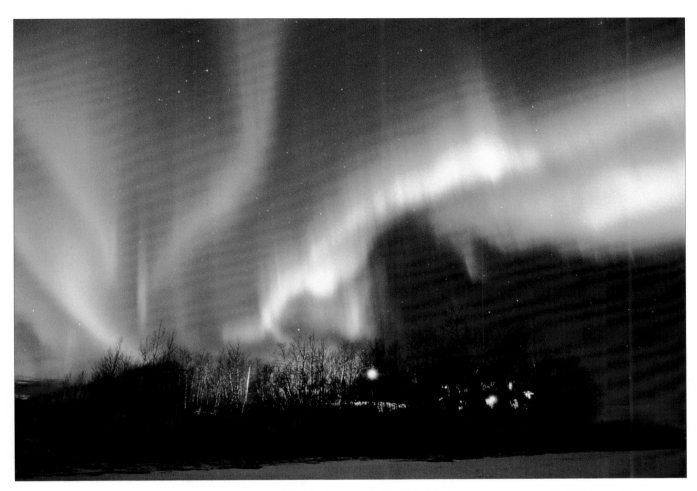

Top: The Aurora Borealis or northern lights are an unforgettable sight. Though they can sometimes be seen in the southern part of the province, they are reliably seen almost every clear winter night in the North, dancing across the sky in awe-inspiring waves.

Bottom: The white pelican is a huge bird with a wingspan up to three metres. There are several nesting colonies in Alberta where the birds spend the summer months after wintering near the Gulf of Mexico.

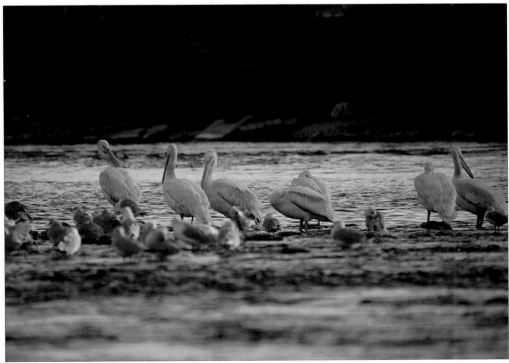

Andrew Bradley was born in Melbourne, Australia in 1962. His love of photography and taste for adventure have taken him from the depths of Australia's Great Barrier Reef to the lofty heights of the Canadian Rockies.

As an avid photographer, Andrew left his home in 1990 to travel the globe, and in 1996 found a home on the prairies in Calgary, Alberta. He recently launched his own stock photography business, www.canSTOCK.ca, that specializes in Canadian imagery.

A Portrait of Alberta is Andrew's third publication — after *A Portrait of Calgary* and *A Portrait of Edmonton and Northern Alberta* — to focus on one of Canada's most diverse and prosperous provinces. This book features the very best of over 4,000 images, garnered over ten years of travelling throughout the province.

Main photo: Steepbanks Lake in northern Alberta

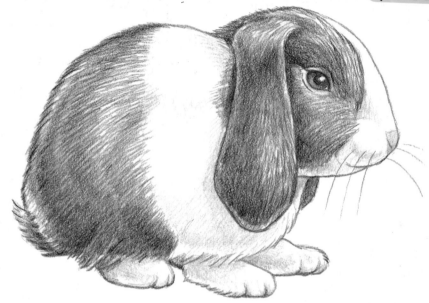

Draw and Color
Pets

Learn to draw and color 23 favorite
animals, step by easy step,
shape by simple shape!

Illustrated by Peter Mueller

Getting Started

When you **look** closely at the **drawings** in this book, you'll notice that they're made up of basic shapes, such as circles, triangles, and rectangles. To draw all your favorite animal friends, just start with simple shapes as you see here. It's easy and fun!

Circles are used to draw a standing dog's chest and hips.

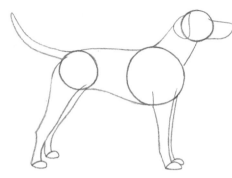 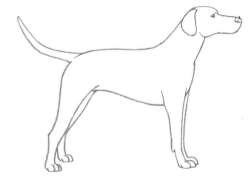

Ovals are good for starting out almost any kind of fish!

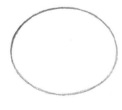 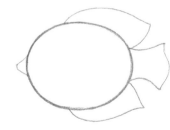 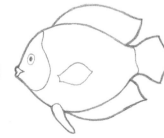

Triangles are best for angled parts, like a snake's head.

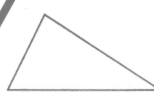

2

Coloring Tips

There's more than one way to bring your **pet pals** to life on paper—you can use crayons, markers, or colored pencils. Just be sure you have plenty of natural colors—black, brown, gray, and white, plus yellow, orange, and red.

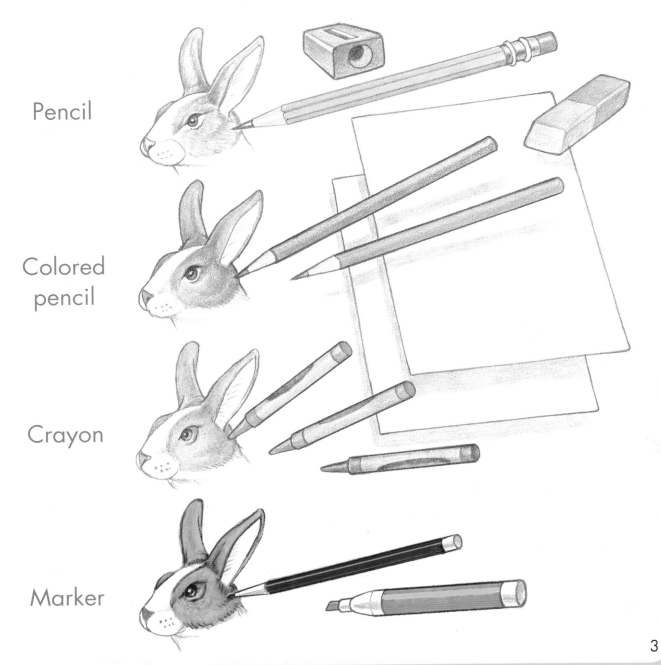

Pencil

Colored pencil

Crayon

Marker

Puppy

This **lovable** Lab is still a youngster, so it has a **chubby** body. Begin with an oval for the tummy and a circle for the head.

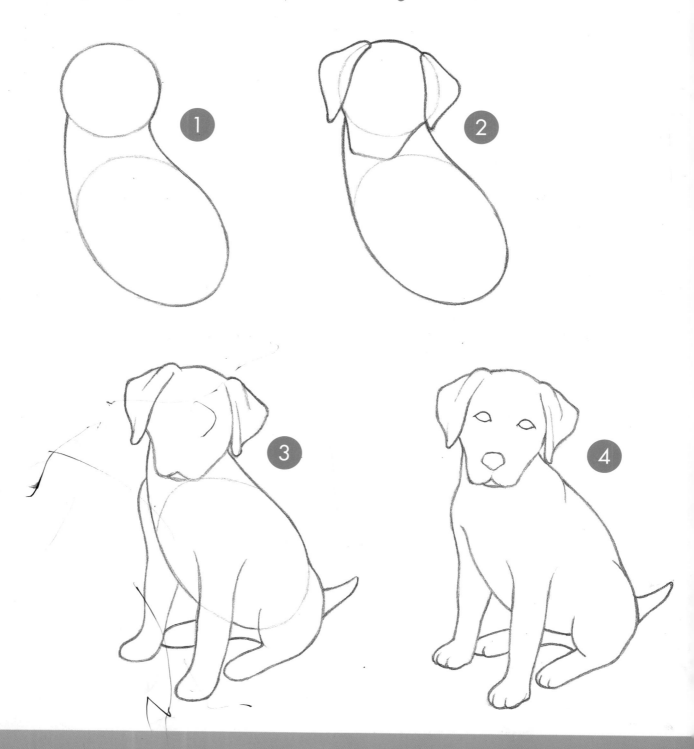

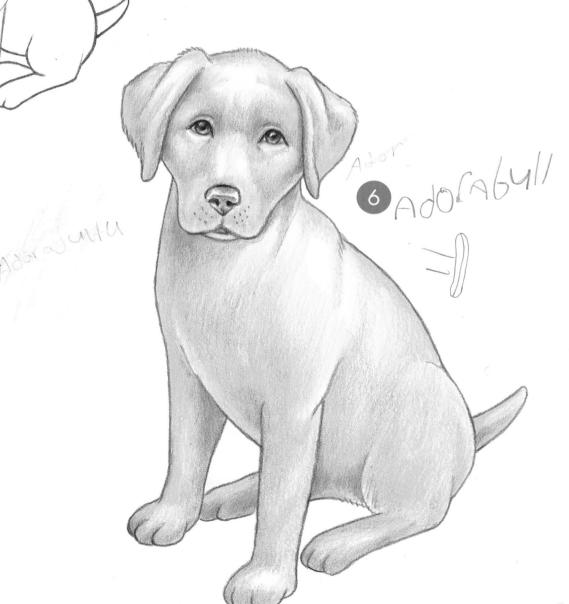

fun fact

Even puppies who are "free to a good home" need care and upkeep—and that takes cash. So how much can you expect to spend on that doggie in the window? Get out your piggy bank! On average, it costs $6400 to raise one medium-sized dog from a puppy to the age of 11.

5

6 AdorAbull

AdoraJuhu

Kitten

This tiny **tabby** has a **fluffy** body and short, thick legs.
Its round eyes and triangular ears look huge on its little furry frame!

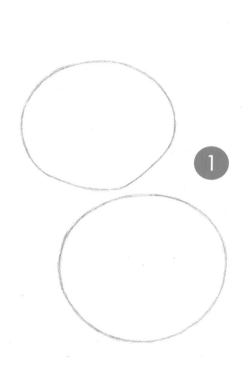

1

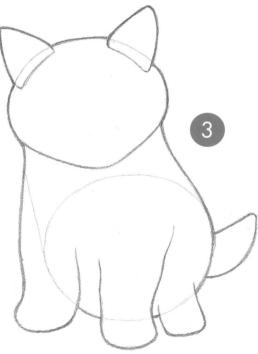

2

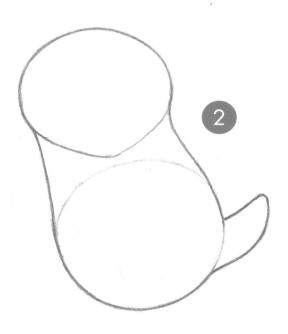

3

fun fact

Cats have excellent hearing and very flexible ears! They have 30 outer-ear muscles, which can rotate each ear a full 180 degrees. So felines can hear in all directions without moving their heads, which helps them pinpoint where sounds are coming from.

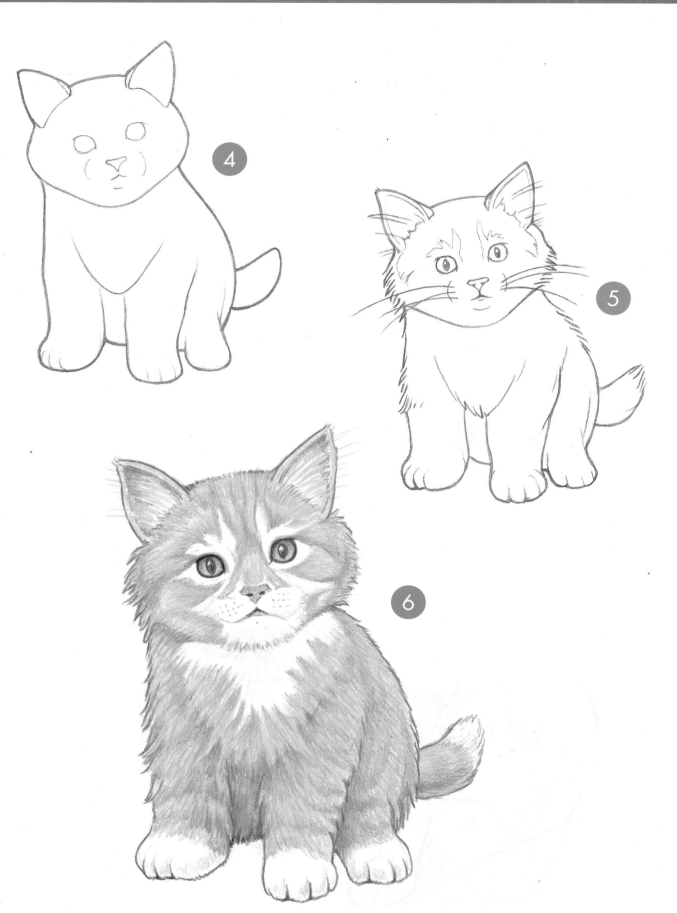

Macaw

Use an oval to draw this **colorful**, exotic **parrot's** body. The bird's long feathers come to a point—so does its sharp, curved beak!

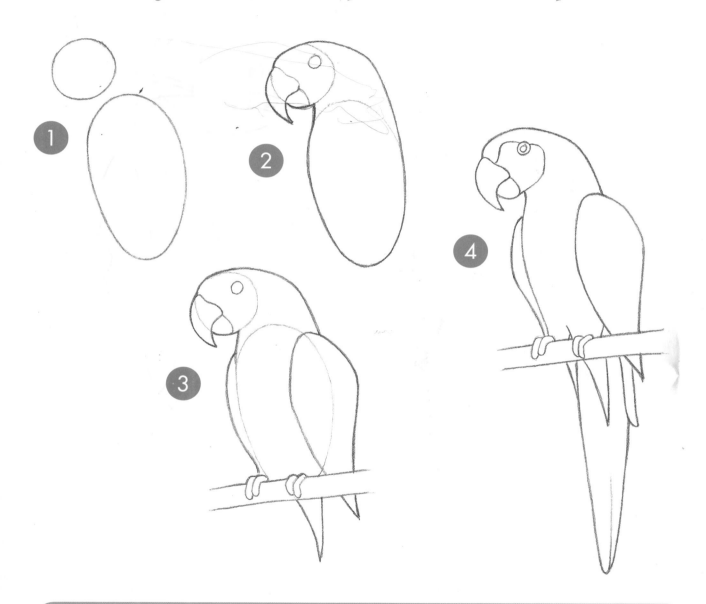

fun fact

Most people know that a macaw's beak is powerful— it's so strong that it can easily crush a Brazil nut! But what's less well known is that a macaw also use its dry, scaly tongue as a tool. A bone inside the tongue helps the bird break open and eat food.

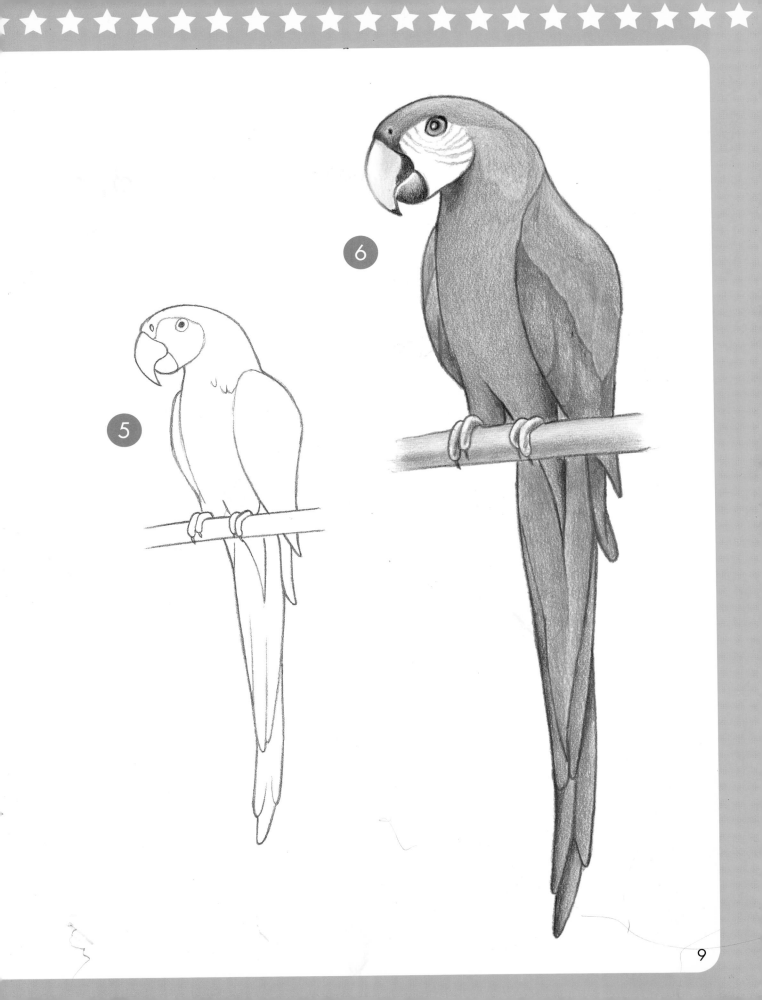

Bunny

This **Lop-eared** rabbit's body is **round,** but it isn't a perfect circle. Its long ears droop down, but its short tail swoops up!

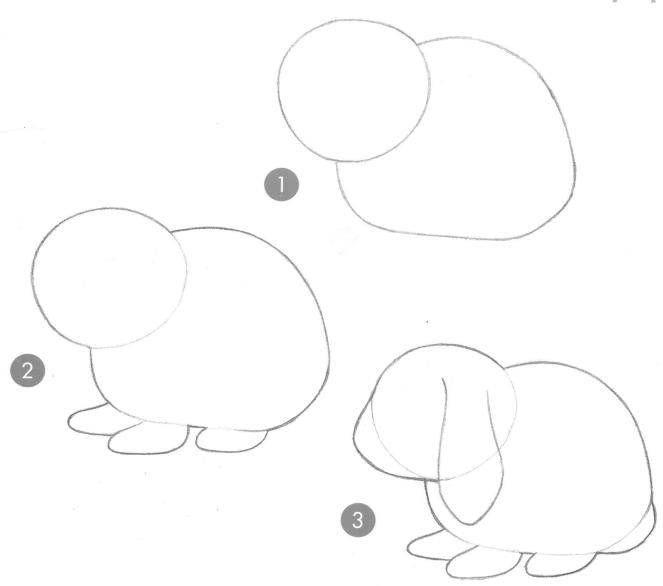

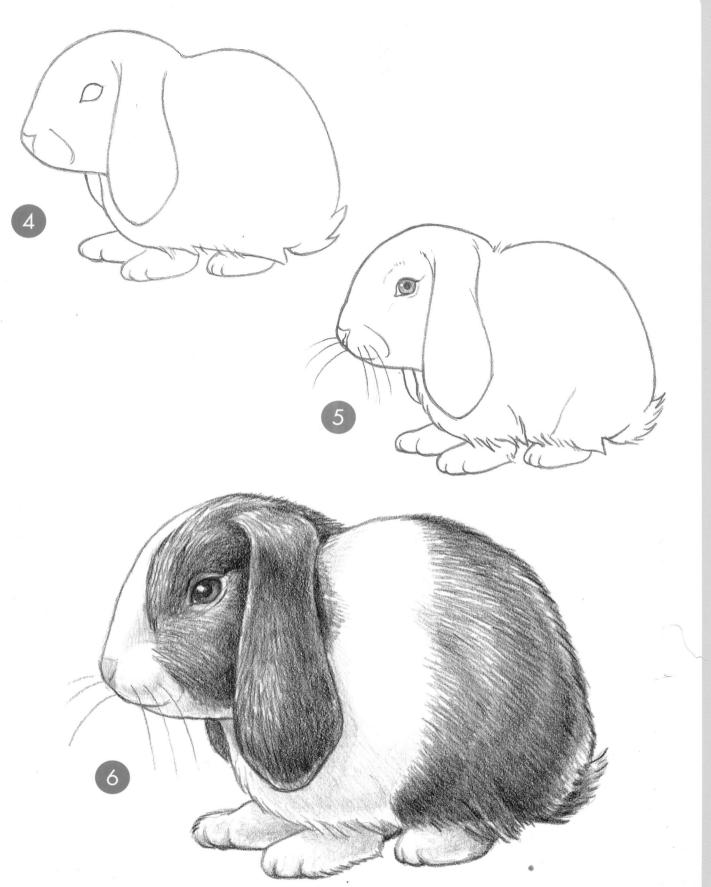

Frog

It isn't easy being **green!** This **amphibian** has a few unusual features, like legs that fold and eyes that sit on top of its head!

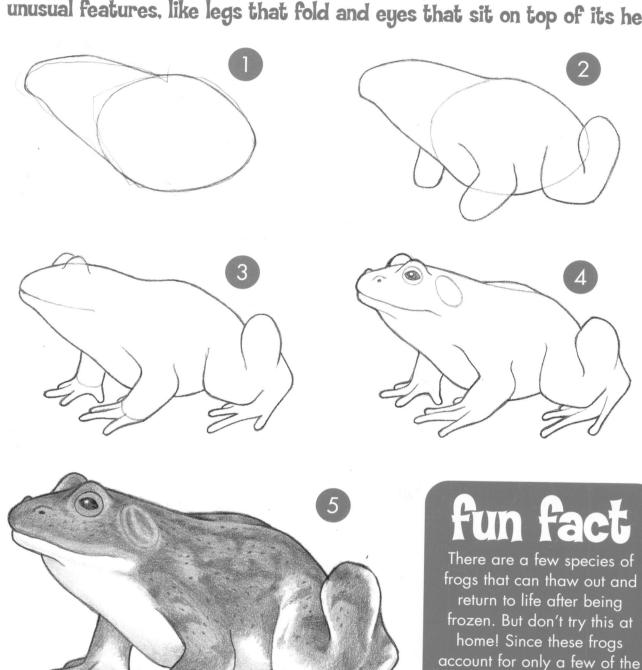

fun fact

There are a few species of frogs that can thaw out and return to life after being frozen. But don't try this at home! Since these frogs account for only a few of the 2600 known frog species, you don't want to experiment on your hip-hopper!

Mouse

This **little** mammal has tiny **rodent** features: small, round eyes; a tiny pink nose; a long, thin tail; and itty, bitty toenails!

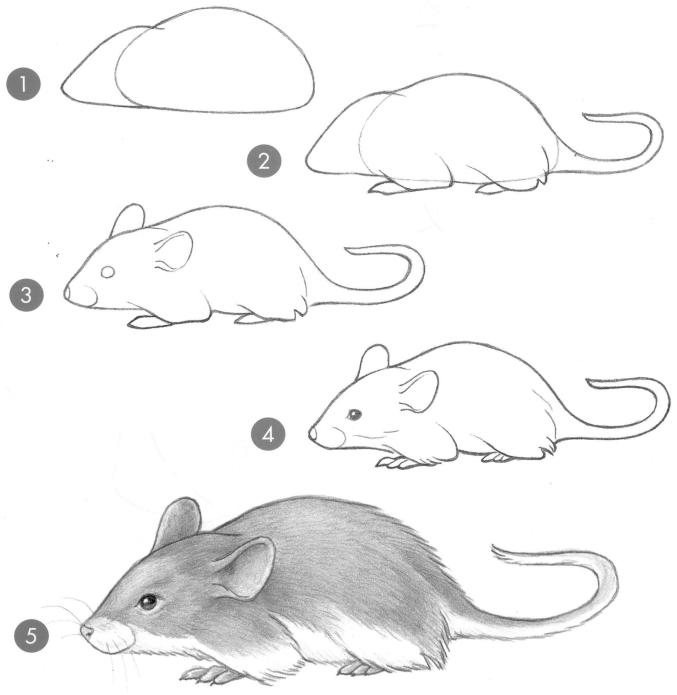

Ferret

With its **slim** body and small head, the ferret looks similar to a **cat!**
But its rounded ears and masked markings distinguish it from most pets.

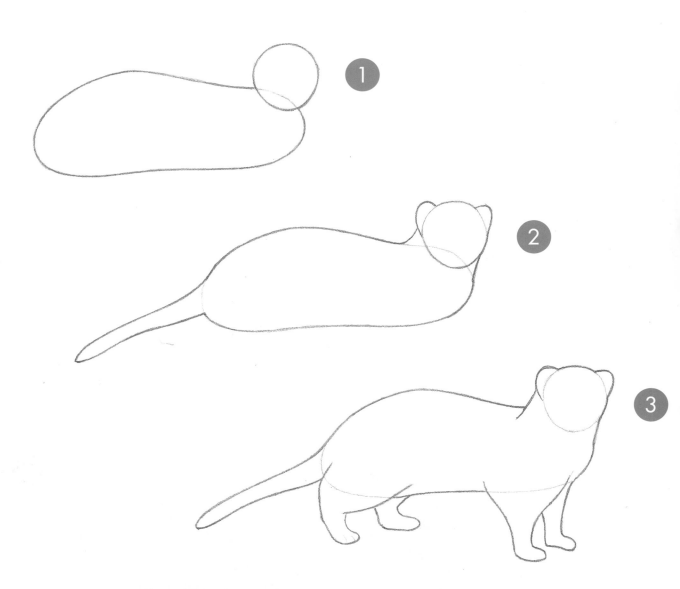

fun fact

Ferrets have been domesticated for even longer than cats have. Yet the approximately 8 million domestic ferrets in the United States aren't officially recognized as pets by any state government, and it's illegal to own these furry friends in the state of California!

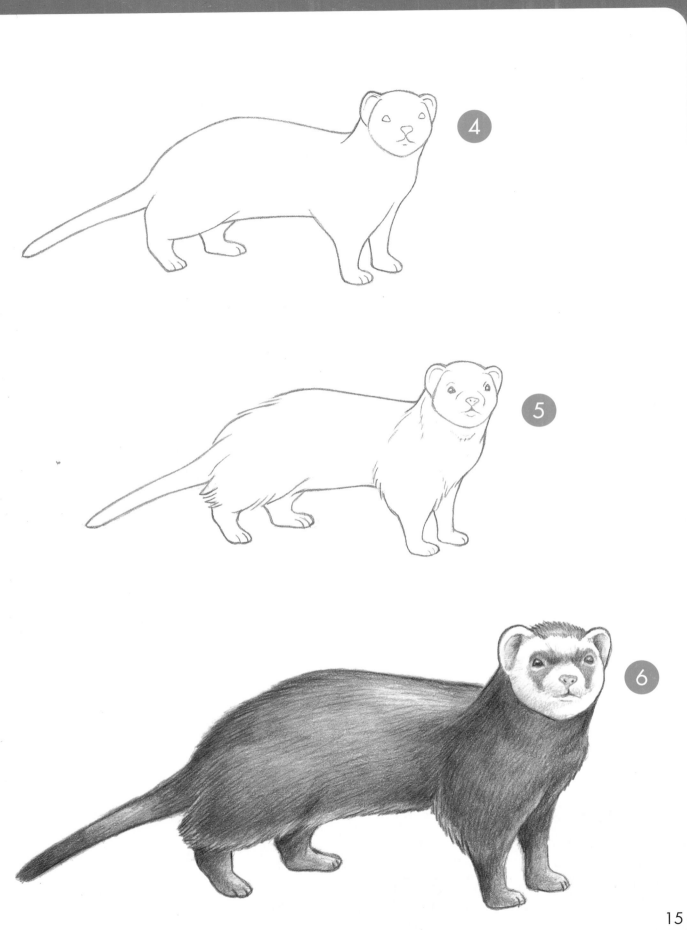

Horse

Start this horse on the right **track** by drawing the **main** shapes: two circles for the hips and chest. Then trot along to the other parts!

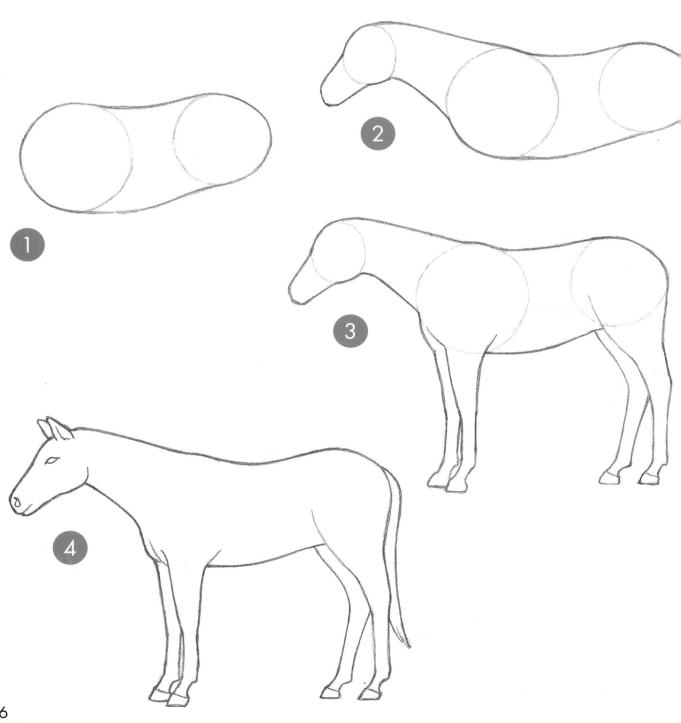

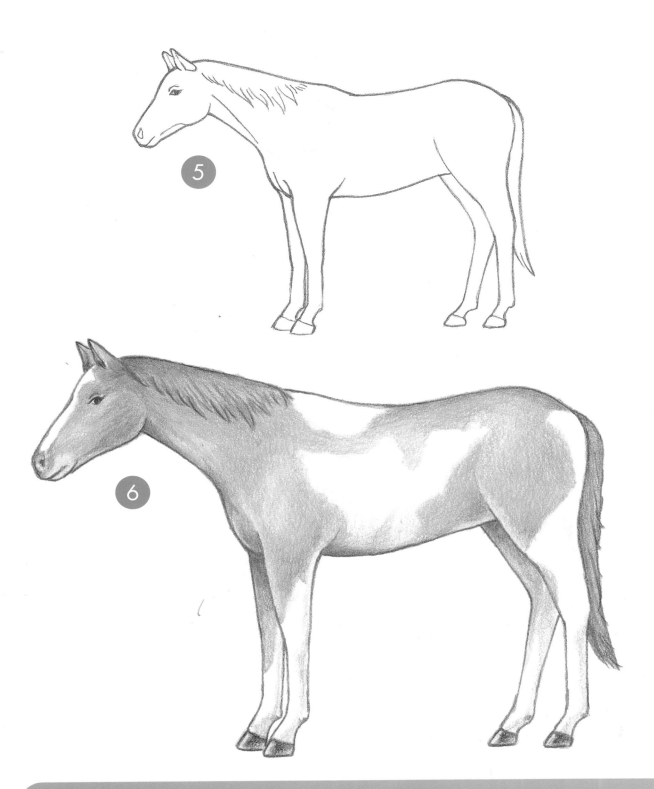

5

6

fun fact

Horses don't lay eggs or raise tadpoles, but they do reproduce frogs. Confused? The soft underside of a horse's hoof is called a "frog." The frog sheds every time there is new growth, which happens several times each year.

Betta

Male Japanese fighting fish are known for their large, colorful fins, which they proudly display when they meet another male fish!

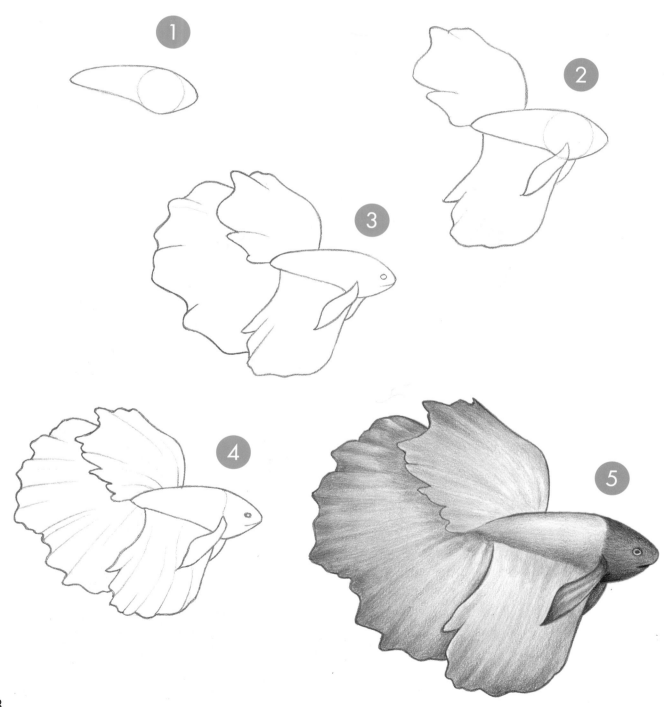

Cockatiel

The cockatiel's **crown** of feathers **stands up** when the bird is excited, but it lies flat and curls at the end when the bird is calm.

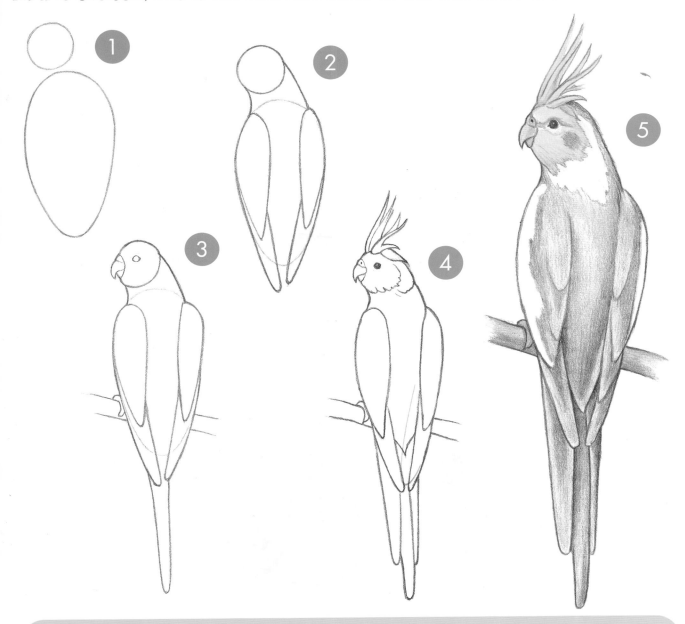

fun fact

Because it's a social bird, your cockatiel might enjoy having a pet of its own! Experts say canaries make good pets for cockatiels. But don't expect your 'tiel to take care of the canary's feeding and cleanup; those will be your responsibilities!

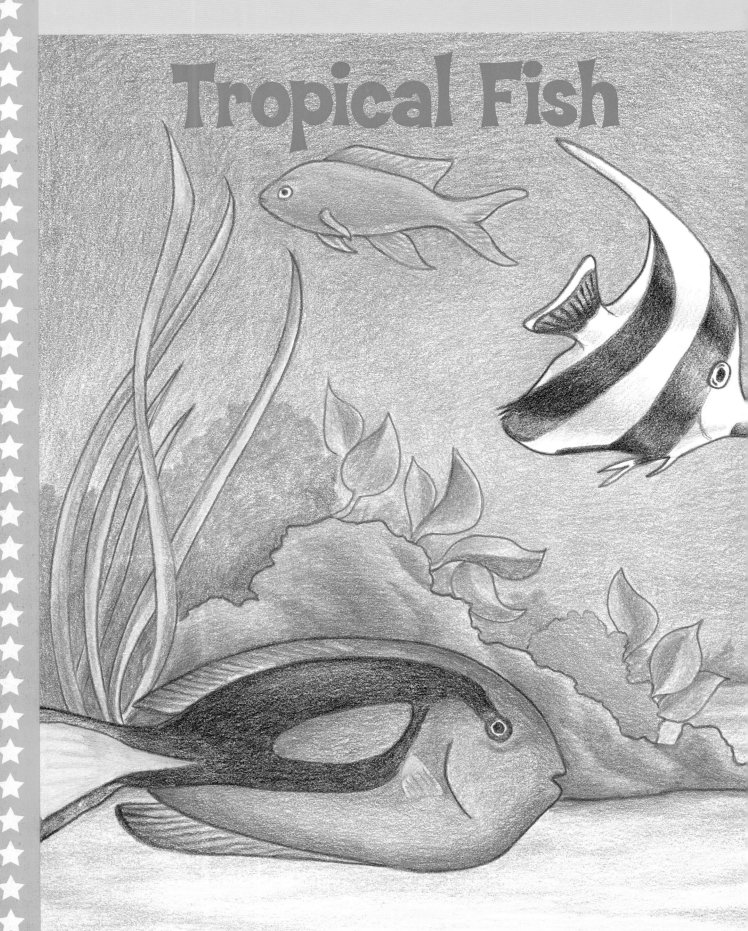

Why stop at one **fish** when you can draw a whole aquarium? Fill the water with Yellow Tangs, Moorish Idols, Blowfish, and more!

Dog

A **Rottweiler** has a thick, stocky body and a **big** head. Draw this powerful dog with strong legs, a square jaw, and a straight back.

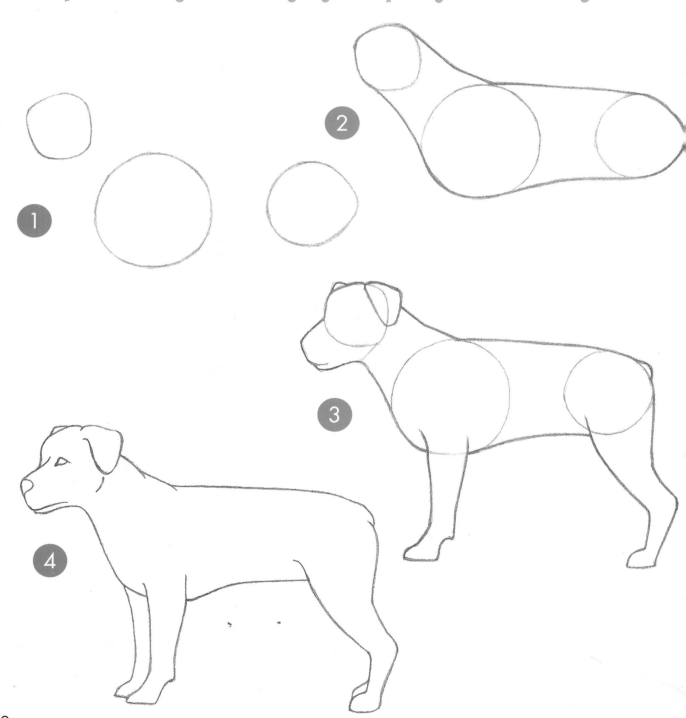

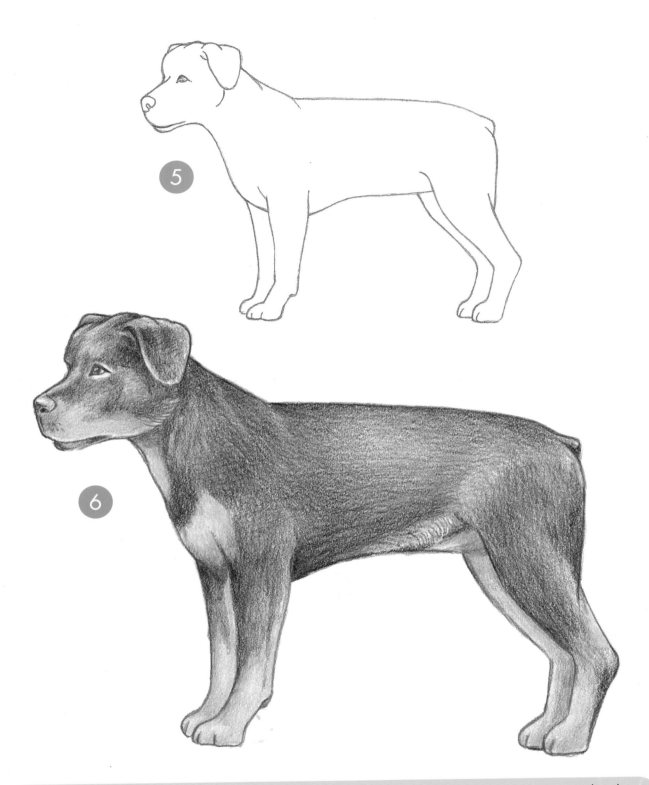

5

6

fun fact

Many people incorrectly believe that the Canary Islands, located in Spain, were named after the bird. Actually, the islands were named after the Latin *Canariae insulae*, where "Canariae" refers to a large breed of dogs from Roman times. So the islands' name really means "Isle of Dogs"!

Iguana

When you draw this **scaly**, sun-loving **reptile**, be sure to make its tail longer than its head and body combined!

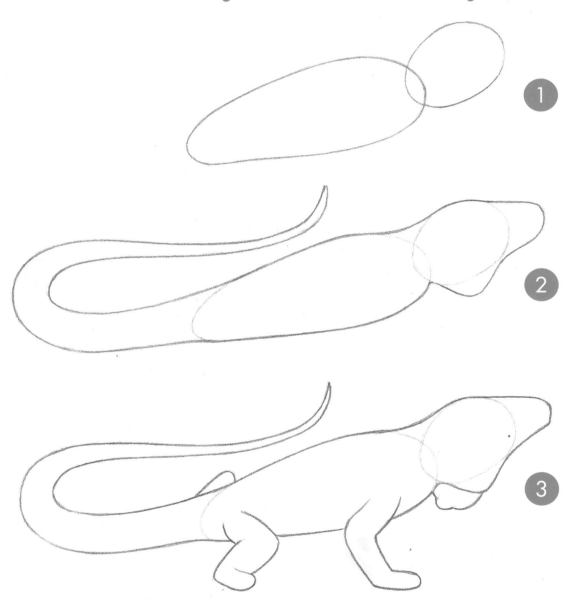

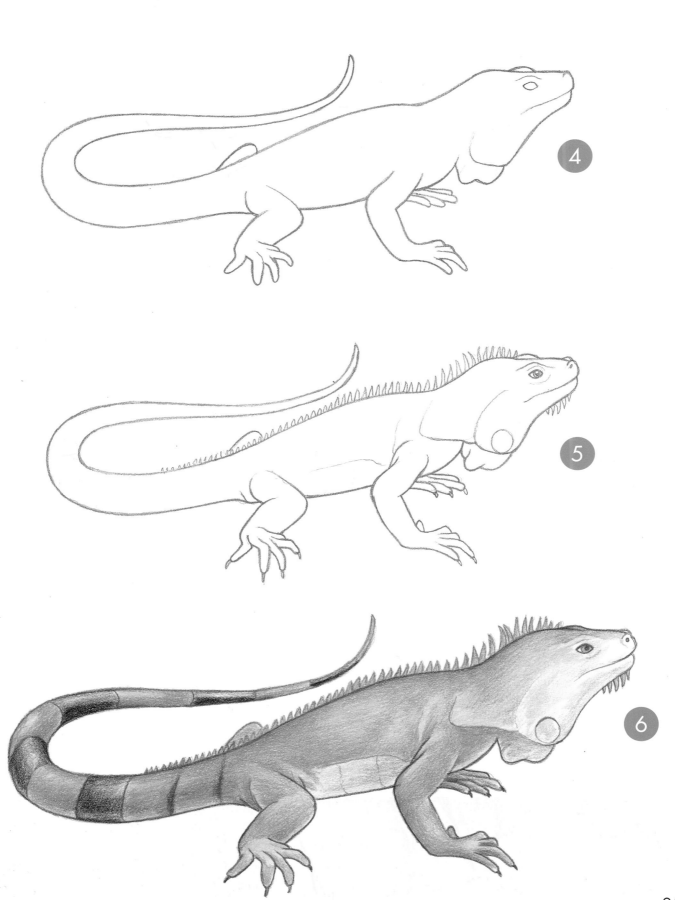

25

Short-Haired Cat

It's easy to **spot** this **feline's** shape because of its short coat! Start drawing this regal Bengal's body with a tall bean shape.

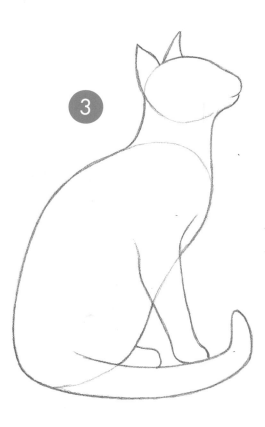

fun fact

Do you see a resemblance between your kitty and the big cats at the zoo? It may be because your house cat is part wild cat. The first house cats—domesticated more than 4000 years ago—were descendants of African and European wild cats!

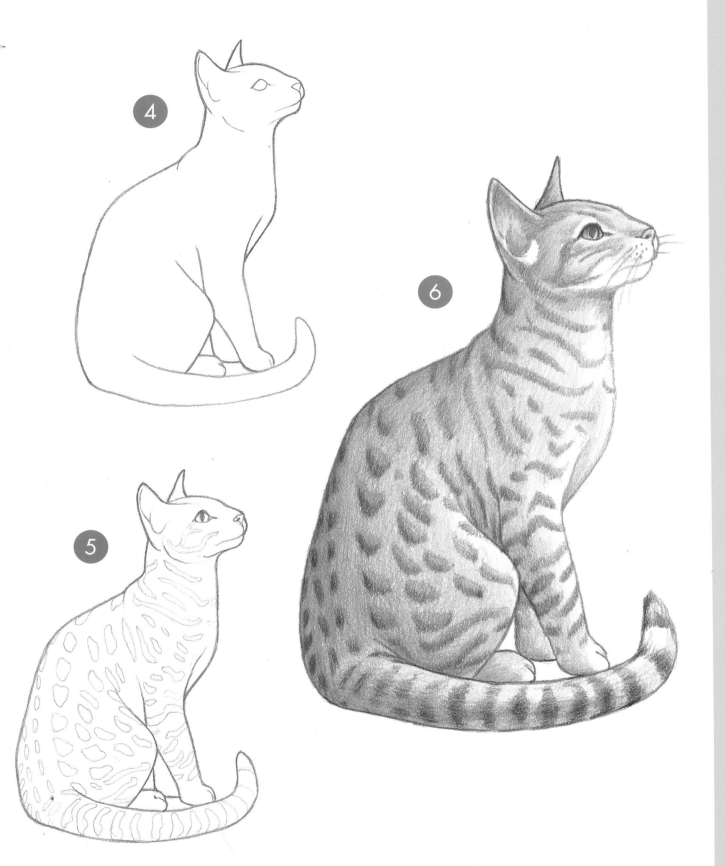

Parakeets

This **pair** of parakeets starts out with **similar** shapes, but the birds aren't identical. Look for the differences as you draw.

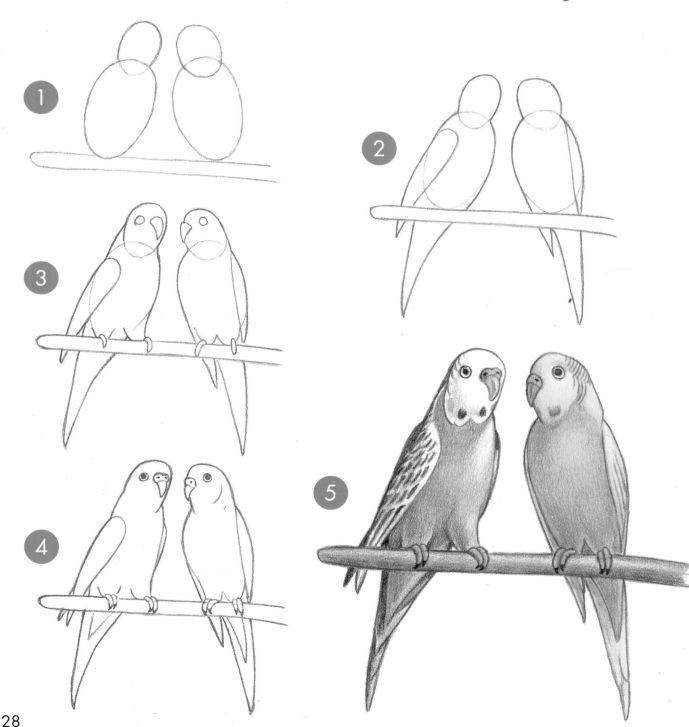

Goldfish

Like a game of **Go Fish**, drawing this goldfish is as simple as can be! Begin with an egg shape for the body, and then add the flowing fins!

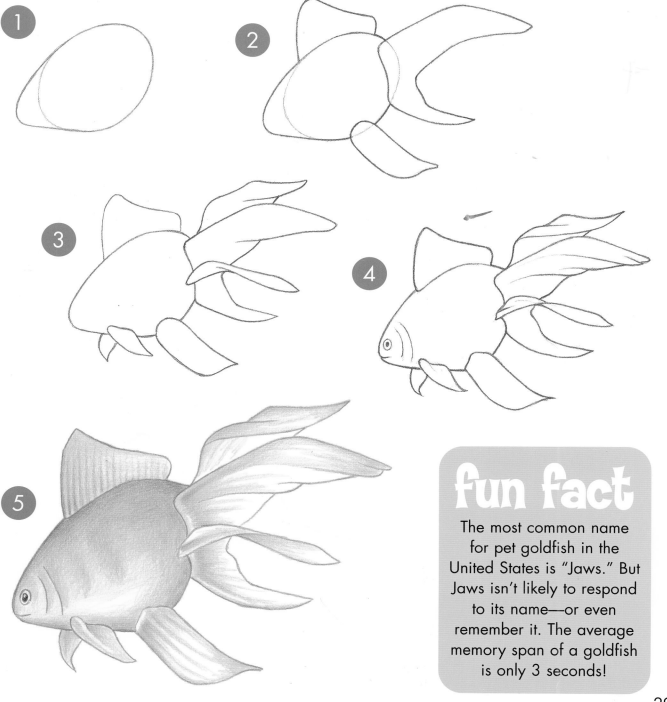

fun fact

The most common name for pet goldfish in the United States is "Jaws." But Jaws isn't likely to respond to its name—or even remember it. The average memory span of a goldfish is only 3 seconds!

Pot-Bellied Pig

"Porkers" like this one love to **pig** out, so it's no surprise that this swine's most recognizable feature is its big round belly.

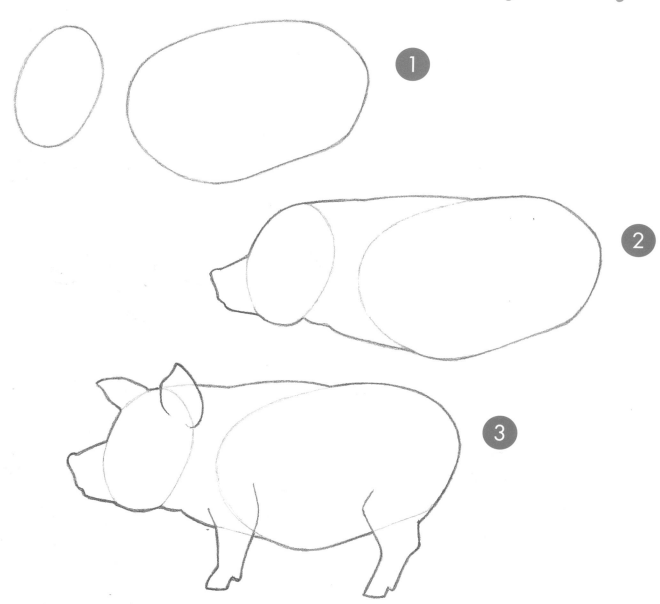

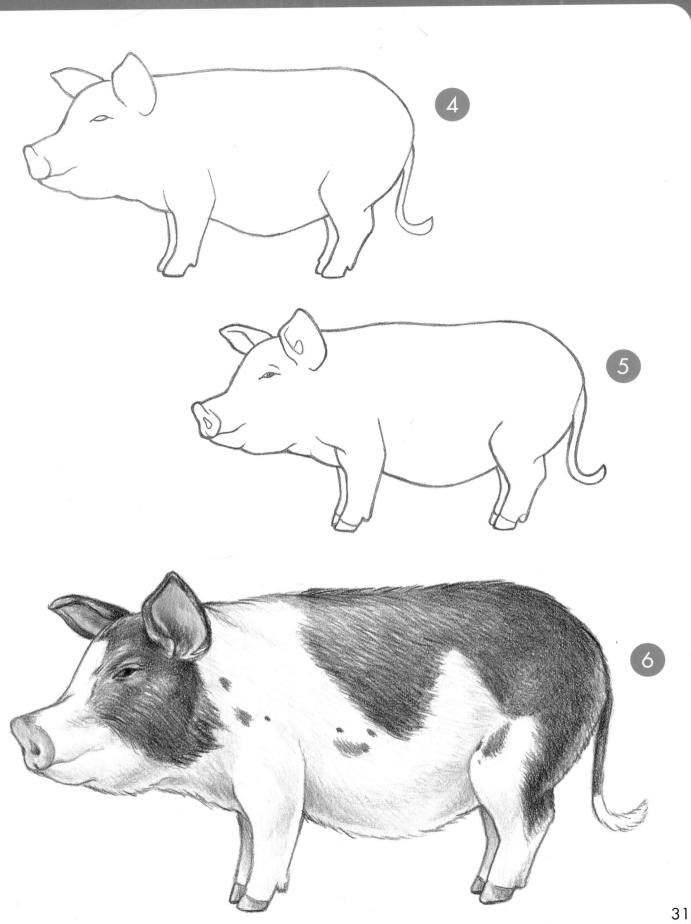

Snake

S-s-s-start with two oval shapes to **snake** yourself into position to draw this slithery coiled Python.

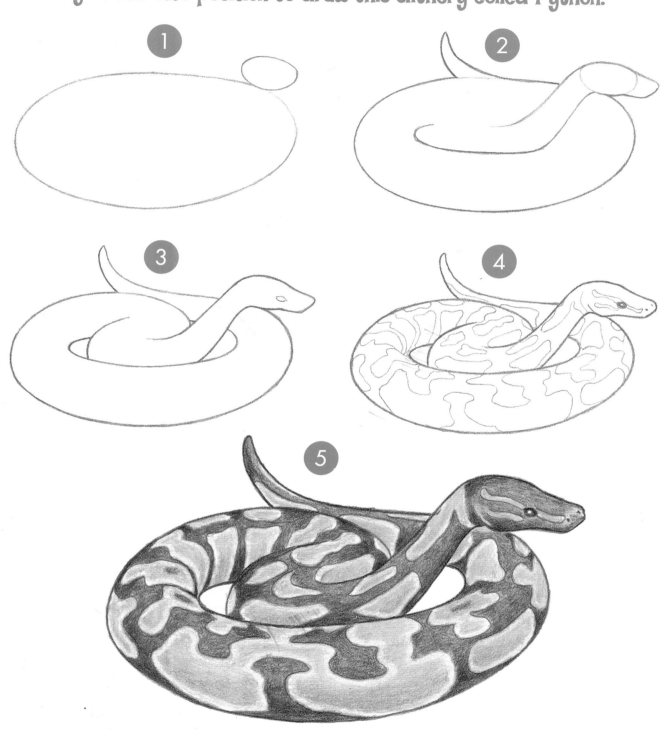

Hermit Crab

Like all **hermits,** this crab prefers to be **alone.** And there's no better place to retreat from the world than inside a shell!

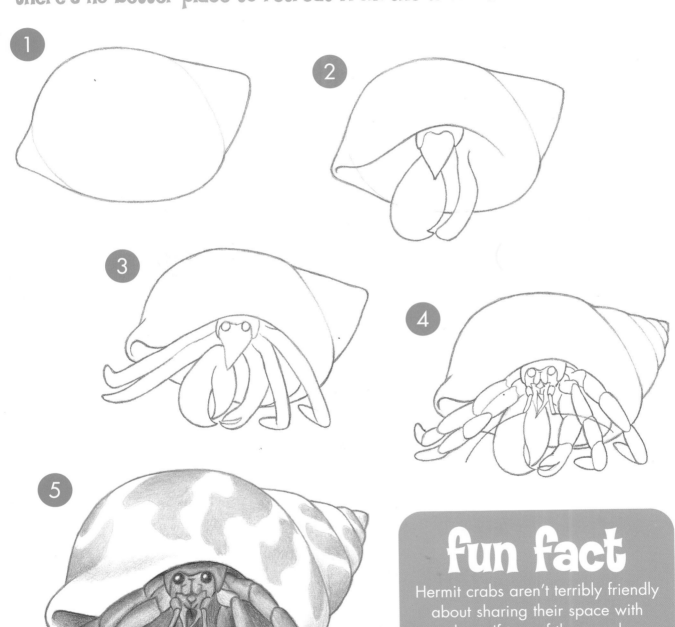

1

2

3

4

5

fun fact

Hermit crabs aren't terribly friendly about sharing their space with others. If two of these crabs encounter one another, watch the claws fly: The hermits will battle it out until one falls out of its shell.

Pony

Ponies are **shorter** than horses, but they're usually stronger as well! Draw this pet with a thick body and muscular legs.

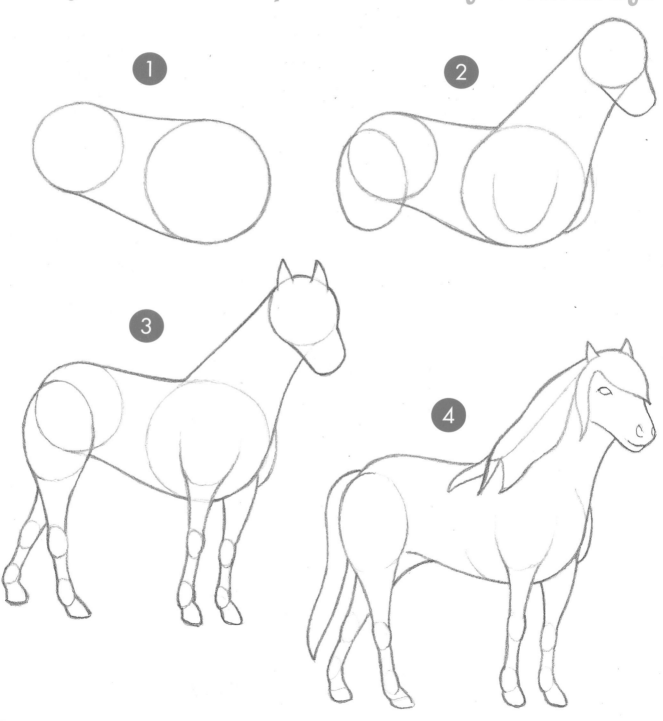

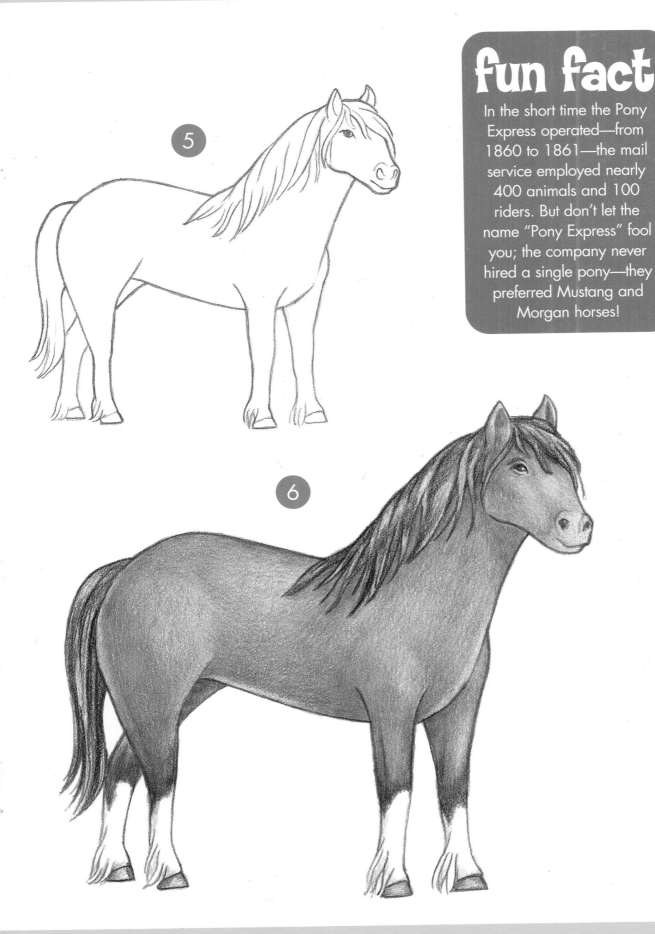

5

6

35

fun fact

In the short time the Pony Express operated—from 1860 to 1861—the mail service employed nearly 400 animals and 100 riders. But don't let the name "Pony Express" fool you; the company never hired a single pony—they preferred Mustang and Morgan horses!

Tarantula

An **Arachnid** is a different kind of **"furry"** friend! This spider has eight shaggy legs and two shorter "arms" in front of its body.

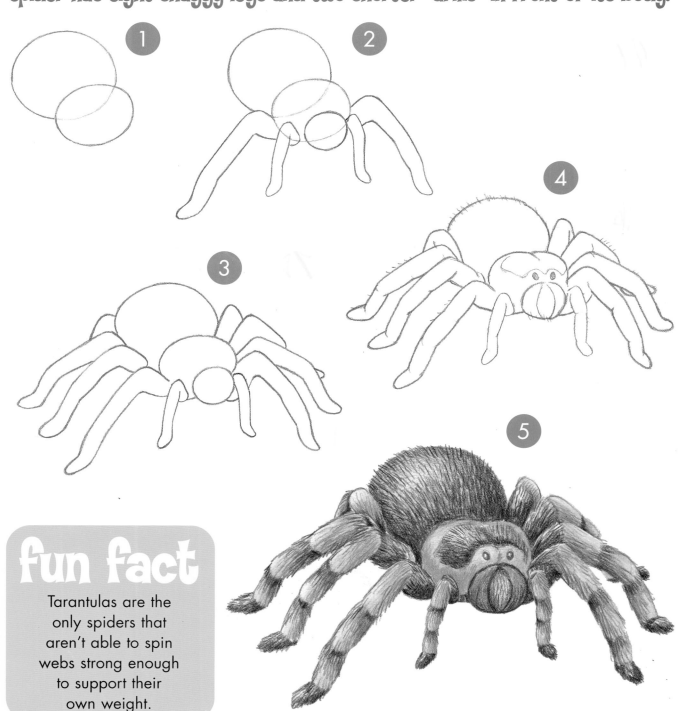

fun fact

Tarantulas are the only spiders that aren't able to spin webs strong enough to support their own weight.

Tortoise

This **shell-back** moves **slowly** because it takes its home wherever it goes! Its four thick, strong legs have to work hard.

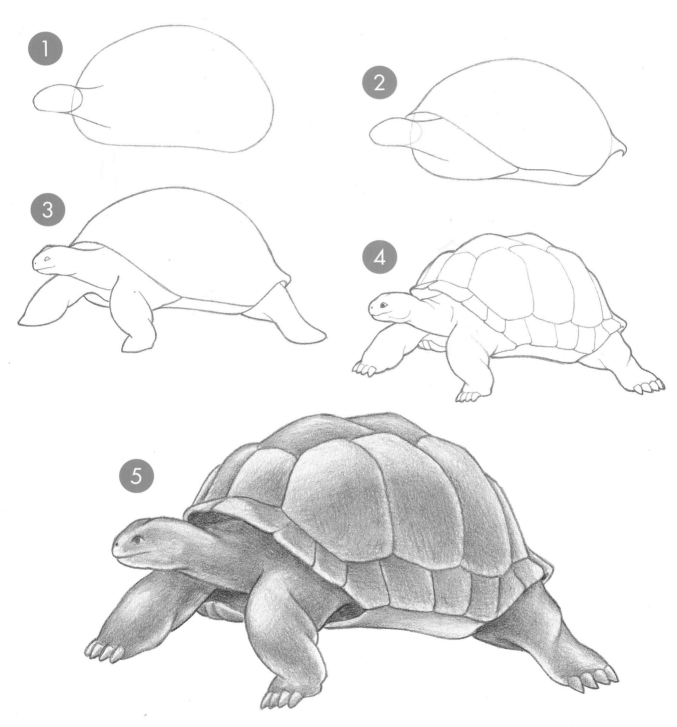

Long-Haired Cat

Is there a **body** under all that **fluff?** Of course! But to draw a purr-fect Persian portrait, just draw the shapes that you can see!

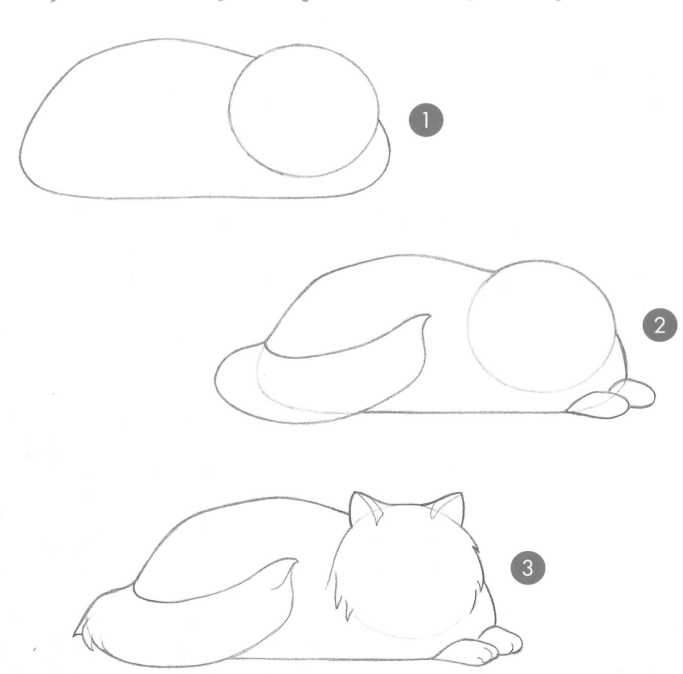

38

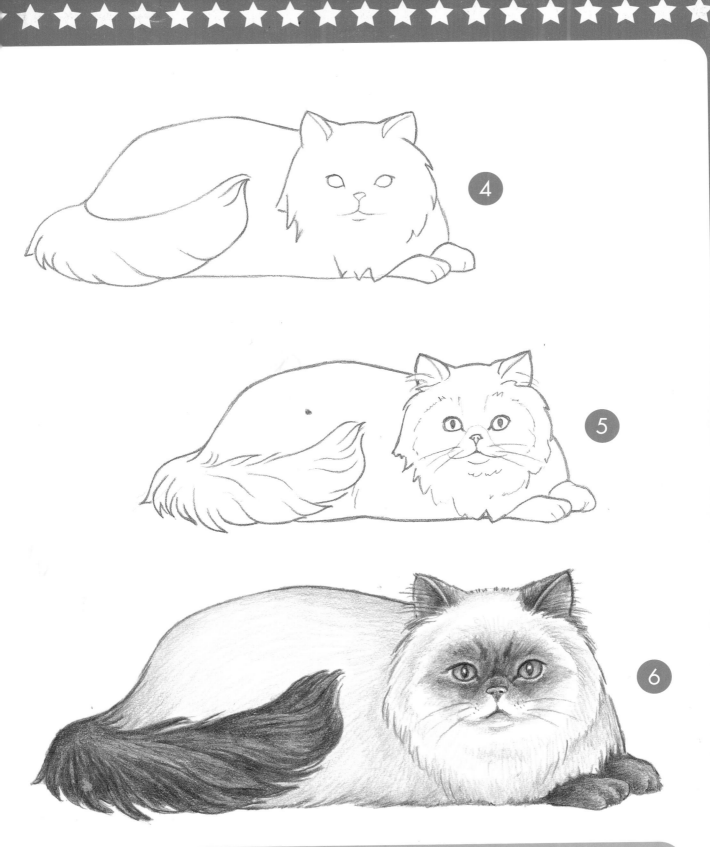

4

5

6

fun fact

The "color point" pattern of cats like the one above is determined by heat! Color-point kittens are born light-colored because they are warm inside their mothers. After birth, the cool temperature areas (or points) of the cat darken.

Guinea Pig

This little **cowlicked furball** is more closely related to mouse than to a pig. It may be the only pet with permanent "bedhead"

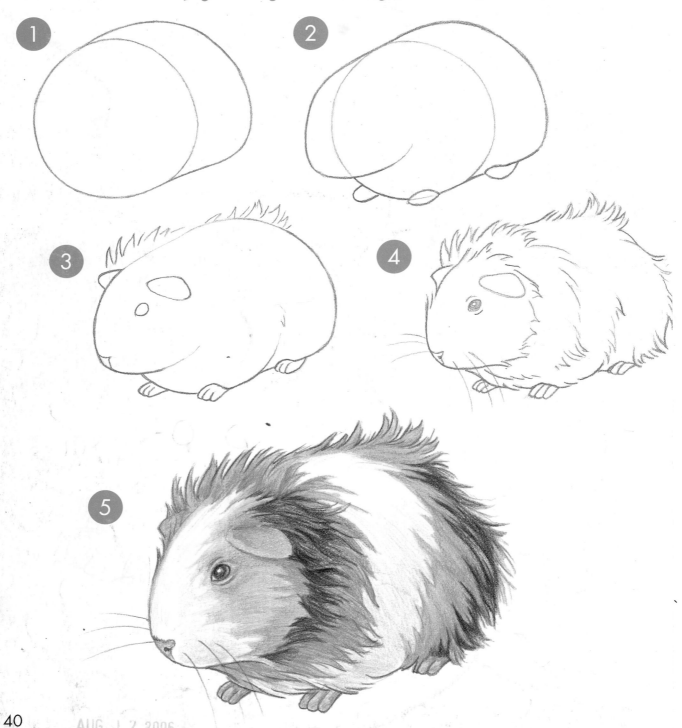

AUG Z 2006